The design concept

Allen Hurlburt

The design concept

Watson-Guptill Publications, New York

Copyright © 1981 by Allen Hurlburt

First published 1981 in the United States and Canada by Watson-Guptill Publications,
a division of Billboard Publications, Inc.,
1515 Broadway, New York, N.Y. 10036

Library of Congress Cataloging in Publication Data
Hurlburt, Allen, 1910–
 The design concept.
 Bibliography: p.
 Includes index.
 1. Graphic arts—Technique. 2. Communication
in art. I. Title.
NC997.H83 741.6 81-7402
ISBN 0-8230-1306-5

Manufactured in U.S.A.

First Printing, 1981

2 3 4 5 6 7 8 9/86

Contents

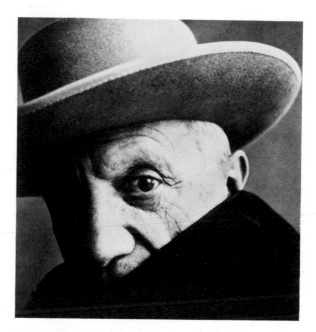

*"It would be interesting to
record photographically
not the steps in making a painting,
but its metamorphoses.
One might be able to see by what
path a mind finds its way towards
the crystalization of an idea."*

Pablo Picasso

Photograph by Irving Penn

Introduction

There is no more rewarding experience in graphic design than that moment when an idea surfaces, when a flash of illumination signals the formation of a concept that is both original and potentially effective. Rare as these moments are, they are worth all of the extra effort and even the extra hours that they sometimes demand. Unfortunately, these moments are also the most difficult part of the design process to understand or explain.

In the three years that it has taken me to put this book together, I have plowed through volumes of information on the creative process. I have reached back into my own design experience, which bridges several decades of graphic design, and measured my experience against that of scores of outstanding designers that good fortune brought me close to. My exploration of concept formation produced no easy answers, but I did uncover a body of knowledge that may prove useful to graphic designers who want to expand their creative capacity.

When we speak of the natural talent of artists or graphic designers, we are referring to their imagination and ability to discover fresh and original concepts. There is reason to believe that the capacity to develop creatively is, at least in part, inherent, but there is also considerable evidence that this natural talent needs to be nurtured. The designer who is properly stimulated and who is motivated to enlarge his or her own creative environment will grow and extend the horizon of that talent.

This book is divided into six chapters. The first is a concise review of what is generally known of the creative process and innovative thought. The second chapter relates this process more directly to the procedures a designer follows in his search for creative solutions.

The three following chapters review the specific areas of graphic design and the special demands they place on the designer. The categories range from the persuasive strategies and challenges of advertising and editorial design to informational design, diagraphics, and identification programs where logic sometimes becomes the dominant part of design equation.

The final chapter, which I have elected to call *Connections*, brings together eight American designers who describe in their own words the search for eight outstanding design solutions. All of these designers are members of the Art Directors Hall of Fame, and I am most grateful for their contributions to *The Design Concept*. In many cases these designers' accounts confirm and reinforce the findings of the earlier chapters, and in some cases they shed new light on the search for original design concepts.

It is the intention of this book to draw the graphic designer away from imitative and fashionable approaches—to rekindle the spark that may have illuminated early student work only to be dimmed as technical proficiency took over—to encourage a movement from following patterns to setting them.

The creative process

1

1. The creative process

A creative individual absorbed in solving a problem will be influenced by a broad range of personality characteristics—accumulated perceptual awareness, a capacity for intellectual analysis, emotional responses, and an innate ability to synthesize the elements of a problem into an original idea. The degree to which both intellect and feeling influence the process will be governed by the personality of the designer and the nature of the problem.

The theory of the structure of the mind first advanced by Sigmund Freud, whose study of the mind roughly paralleled chronologically the early phases of the modern art and design movement, provides us with a good starting point for a discussion of the creative process. In his anatomy of the mind, he identified three distinct levels. He placed the *conscious* level at the top, as the simple receptor of surface information and the mechanism for logical analysis. At the lowest level he placed the *unconscious*, as the deep and hidden area where accumulated experience is often isolated and blocked off by inhibition and internal censorship. The term *subconscious* is often used in popular psychology as a synonym for Freud's unconscious, but because it blurs the distinction between the levels, it is rarely used in scientific studies. Between conscious and unconscious, Freud located a third level that he called the *preconscious*. He considered this level to be more accessible than the unconscious—a bridge between the clear deductive mind and the mysterious unconscious. This interim level is probably the origin of what we call intuition, which is the quick and ready insight that produces ideas without the apparent involvement of our conscious thoughts. Some students of creative thought, including many champions of systematic problem solving, tend to minimize the importance of intuition, but most observers consider it to be a critical part of the creative process.

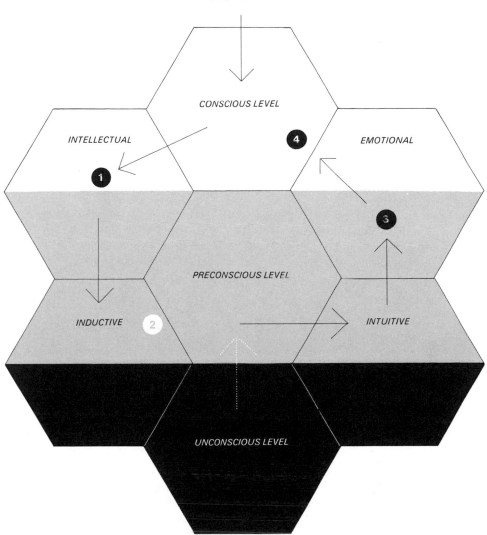

INFORMATION

CONSCIOUS LEVEL

INTELLECTUAL

EMOTIONAL

PRECONSCIOUS LEVEL

INDUCTIVE

INTUITIVE

UNCONSCIOUS LEVEL

Anatomy of the mind: *This diagram illustrates Sigmund Freud's three major levels of consciousness. At the top is the* conscious *level, the receptor of information, and at the bottom is the* unconscious. *In between, Freud locates the* preconscious, *the level that draws on both of the other levels and provides the source for insights and inspirations. The left side of the diagram illustrates the intellectual processes, and the right side, the emotional response. The circled numbers indicate the four generally accepted steps in the creative process: (1) analysis, (2) incubation, (3) inspiration, and (4) verification.*

If the same project were given to a dozen individuals and their progress toward a variety of solutions was observed, a common pattern in their procedures would be apparent. Historically, most observers have accepted four steps as critical parts of the creative process. These are analysis, incubation or remission, inspiration, and verification.

Analysis This initial step in the creative process is comparatively simple to understand because the activity is centered in the deductive or rational level of the mind. It begins with the conscious absorption of all information given for a project, although the facts provided will rarely be sufficient for a final solution. An experienced

designer will know how to extend his knowledge through additional research. He will then combine the new information with what he already knows to establish a basis for a creative solution.

The research on major problems can be demanding and time consuming, and how this is often accomplished will be covered in more detail in subsequent chapters. There are times when the designer can arrive at a solution with only limited information, if this is coupled with experience on similar problems. It is even possible to produce an adequate design solution to some problems by purely logical analysis in the conscious level of the mind. But the really exciting experience will usually come from the deeper probing that leads to fresh and original vision.

Incubation

The second phase of the creative process involves a calm, detached period in which the factual material that has been analyzed and absorbed into the conscious level of the mind can contact and be influenced by the intuitive forces of the preconscious or inductive level of the mind. The word *incubation* may not be an ideal description of this important phase, but it is meant to describe a period of dormancy in which an idea or a solution is being formed without the aid of deductive thinking. Most scholars who have studied the creative process place great emphasis on turning away from the logical perusal of a problem at this stage in order to utilize the intuitive forces of the pre-conscious. There is an impressive amount of evidence that innovation and invention frequently occur during periods of intermission or rest when conscious involvement with the problem is at a low ebb.

Inspiration

This phase of the creative process is perhaps the most crucial and also the most difficult to define. It is sometimes called illumination, and it is a direct outgrowth of the period of incubation and remission. This is where insight, imagination, and intuition blend with the preceding rational analysis to create a synthesis and arrive at a design concept. It is this phase that explains why an inventive genius like Thomas A. Edison could take shortcuts in his search for solutions by seeming to guess at the answer. It also suggests why Albert Einstein's "quick and definite vision" often seemed to replace "the slow and painful" process of thought.

Verification It is never enough that the outcome of the exercise be creative and original. It must also solve the problem in a valid and useful way. The appropriateness of the solution is verified by checking it in terms of original guidelines or information given, research done, and the designer's accumulated knowledge and experience. Wherever possible this phase of assessment is extended to include the response that the finished work generates.

The validity of these four phases of the creative process may be challenged by the designer who has had an idea come to him in a "flash"—often at the very instant that the problem has been stated. In my opinion, this instantaneous creative experience telescopes, rather than bypasses, the four steps. If, for example, the designer has listened long enough to understand the problem and absorb it into the wealth of material that his mind has accumulated, the development of the concept can be remarkably fast. Verification will come later, and there is always the risk that such swiftly achieved concepts will fail the final test.

Lateral thought Another provocative theory about the process of creativity has been advanced by Edward de Bono, a noted psychologist and author. In the introduction of his book called *Lateral Thinking* he describes this method as "closely related to insight, creativity, and humor." He continues, "All four processes have the same basis. But whereas insight, creativity, and humor can only be prayed for, lateral thinking is a more deliberate process. It is as definite a way of using the mind as logical thinking—but a very different way."

Perhaps the simplest explanation of Edward de Bono's approach can be found in his account of the problem of digging a better hole: "It is not possible to dig a hole in a different place by digging the same hole deeper and bigger . . . if a hole is in the wrong place, then no amount of digging is going to put it in the right place. Vertical thinking is digging the same hole deeper; lateral thinking is trying again somewhere else."

Many of de Bono's ideas are best expressed in visual terms, and he has applied his theories directly to many design problems. The illustration on the following page demonstrates how logical progression led to a bland and predictable result, while a change of direction created a more imaginative and less expected result.

Lateral thinking: *This theory of creative action is graphically illustrated in the problem at the right, adapted from Edward de Bono's book* Lateral Thinking *(Harper & Row). In steps one and two, the parallelograms fit together in a logical way, but when the same logic is followed in step three, the result is predictable and bland. A more interesting and more creative solution results when the previous logic is set aside for a fresh and lateral alternative.*

A cliché results from logical progression.

Lateral thinking produces a better solution.

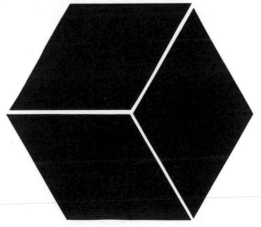

Tangram: *The visual challenge of this ancient Chinese game appeals to the play instinct and can provide visual stimulation to the designer. In Tangram, a tile is divided into seven pieces that can be creatively arranged to form hundreds of pictures of animate and inanimate objects.*

Play instinct

An important part of the creative process is linked to our natural instinct for play—an interest that is most apparent during childhood. Play has been called "the art of childhood." For most children play is a part of the learning process, and for many it is an early training ground for creative thought.

In their preverbal concepts, children filter and record their perceptual experience. They are aware of color and form and link this awareness to their already developed sensory and motor skills by grasping objects with pleasant associations and rejecting those that are disturbing. This visual and tactile exploration of the surrounding world leads gradually to the interpretation of it in terms of space, time, and personal relationships. This is the transition from playful modes to more objective appraisal.

This new objectivity is enhanced by an increased capacity to verbalize experience, but the magic of play returns and becomes a vital part of childhood. It is here that imagination and creative response can be observed, for when children turn to play, they often set aside the objective and verbal for the intuitive and visual.

It is this quality of the unexpected that relates lateral thinking to the turning of an idea with the double meaning we associate with jokes, puns, and illusions.

Play and design

Certain nonverbal games available today bear a direct relationship to the creation of design concepts. One such game is Tangram, an ancient Chinese game, in which a square is divided into seven pieces—five triangles, one square, and one rhombus. These pieces can then be reassembled into a wide variety of forms representing birds, animals, people and objects (see page 15).

Tangrams provide excellent training exercises that will encourage student designers to solve problems creatively. The game's emphasis on simplicity helps to develop the ability to create abstract images and recognizable objects using limited means. By working within these limitations the designer will acquire some of the discipline that will prepare him for the constraints of actual problem solving.

Another game that develops skills in dimensional design is the use of blocks invented by Friederick Froebel, the originator of the kindergarten. Frank Lloyd Wright played with Froebel blocks when he was six or seven years old, and they quite possibly had a bearing on his creative attitude toward form. Throughout his career Wright had a warm recollection of his childhood and has associated play with the dynamics of his architecture.

A documentation of the importance of the play instinct in modern art is hardly needed. Picasso once remarked, as he admired some art by children, "When I was their age I could draw like Raphael. It has taken me a lifetime to learn to draw like them." Many of Picasso's paintings and his playful use of toys and objects in his sculpture reflect this interest in the childlike approach. Also, Henri Matisse's late work with scissored cutouts had a strong similarity to the paper dolls of children.

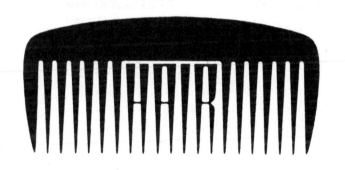

Words and images: *This somewhat playful trademark was developed for Mr. And Mrs. Aubrey Hair by graphic designer Woody Purdy of the Richards Group.*

Word games

When a child moves from the visual, tactile world into the verbal world, he begins to apply his love of play to the use of words. He is intrigued by the ways words rhyme and often invents his own rhyming combinations. His fascination continues with the onomatopoetic sounds of words like "bang" and "choo-choo." As he grows and adds to his knowledge and vocabulary, he incorporates playful attitudes toward similes and metaphors that deal intricately with the meaning of words.

The child's playful attitude toward language is part of the learning process, but it is also further evidence of his early creative ability.

MOTHER

Word play: *No other contemporary graphic designer uses the plastic form of letters more effectively than Herb Lubalin. This is his classic design of a logotype for a proposed magazine called* Mother and Child. *Alan Peckolick who is associated with Herb Lubalin is also noted for his graphic use of words. He designed the book cover at right for* Beards *written by Reginald Reynolds.*

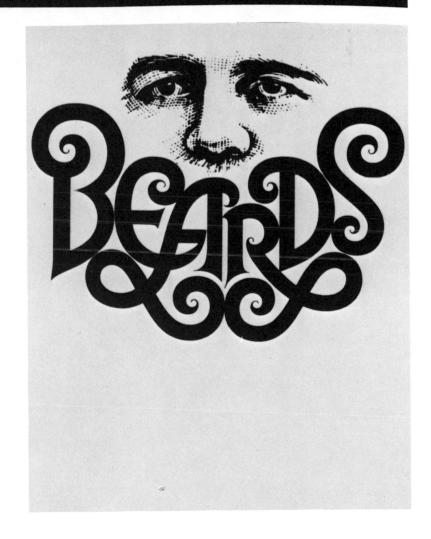

Cutouts: *In this brightly colored collage from the Jazz series for Tériade in 1947, Matisse's childlike cutouts achieve an original effect.*

Unfortunately, too many designers have grown up too soon and forgotten how the interplay of the meaning and sound of words can contribute to contemporary creative concepts.

The use of words—their sounds, their meanings, and their collective letterforms—has been an intriguing aspect of design since the invention of the alphabet. Contemporary designers continue to use this play with words in their design concepts (see pages 16–17), and this form of play can be an extremely important part of typographic training.

It would be inaccurate to imply that this is the only or primary way that words influence creative thinking, but it is important to note here that too many designers are prone to search out visual ideas with too little regard for word content and meaning. A picture may be worth a thousand words, but as one wit pointed out, "It takes words to say that."

Humor The ability to laugh and cause others to laugh can often open the way to new and original ideas. Sigmund Freud found humor of sufficient importance to make it the subject of one of his studies. In "Jokes and Their Relation to the Unconscious," he probed this kinship between humor and creative insight. Many creative people find that they are able to relax from mental tension by turning to the lightness and sometimes unexpected ambiguity of

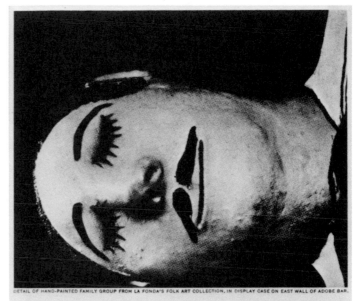

DETAIL OF HAND-PAINTED FAMILY GROUP FROM LA FONDA'S FOLK ART COLLECTION, IN DISPLAY CASE ON EAST WALL OF ADOBE BAR.

No, No, Stupido, we said <u>Fiesta</u> at La Fonda del Sol, not <u>Siesta</u>.

Every Sunday, from one o'clock on, La Fonda has Fiesta. We have the Canela Trio. A Mariache band. The Jose Montalvo Trio. Mexican Hat Dancers. Jose Bettencourt's Marimba Band. A flamenco guitarist. Free granizados (ices) for the kids. And food! Well, you know those La Fonda portions. La Fonda del Sol, 123 W. 50th St., PLaza 7-8800

19

Humor: *George Lois uses a humorous twist in this small advertisement for a restaurant called La Fonda del Sol in New York City. The simple pun emphasizes that there is nothing dull about a Sunday meal at this restaurant. The copy was written by Julian Koenig.*

jokes and anecdotes. The irrelevance and occasional irreverence of these forms of humor can often lead to the detached state of mind that may precede the discovery of fresh viewpoints.

On occasion the concept itself may be based on a humorous idea. Many of the concepts illustrated in this book include amusing ideas or use touches of humor to enhance their presentation. The advertisement for La Fonda del Sol by George Lois and Julian Koenig combines a verbal pun with visual wit to make its persuasive point. The visual and verbal humor of the stage and cabaret has had an easy transition to the television screen, and few commercials can succeed without a sense of humor.

Summary

This chapter has explored some of the accumulated knowledge about the creative process to provide the designer with a background for the search for original ideas. Separation of the process into a series of distinct stages may have oversimplified this complex process. In reality, the search is often more comprehensive and continuous than these steps imply. Both the inductive and deductive forces of the mind are often blended on the journey to a synthesis or completed concept. In spite of these reservations, the steps are probably the best framework for a study of this intricate process.

Analysis, the first step, involves the conscious levels of the mind in a logical and deductive survey of the factual material available

to the designer, but even as the material is being explored, most designers' minds will be in touch with stored perceptual experience and associations as the search for avenues to a creative solution.

Incubation, the second phase, may take many forms. It is related to Freud's period of remission and its purpose is to free the mind from the pressures of the analytical phase. It also permits the intuitive forces identified with the preconscious level of the mind to join the problem-solving procedure.

Inspiration, the third phase, is the most difficult to define, but for those who seek fresh answers to problems and who seek new directions, it is an essential ingredient. While this study has agreed with the need for frequent detachment from conventional thought patterns, it does not ignore the need for constant intellectual appraisal.

Verification, the final phase, weighs the design concept against the stated objectives and the known facts about the problem. It measures the practicality of the solution in terms of its final presentation and may extend to cover the response to its ultimate use.

Most forms of play, including puzzles and games, call on the same innate faculties of the preconscious mind that are involved in creative problem solving. For that reason the play principle, whether it is applied to words or images, stands as one of the best means of expanding creative capacity or reawakening a talent that may have become dormant. Humor, like play, can be an instrument for the relaxation of the mind and can reduce over-concentration. It can also be the primary means of communicating the design concept.

One of the most important sources of visual ideas is our accumulated perceptual experience—the visual record that is stored for future retrieval. This may explain, in part, how Pablo Picasso's fascination with primitive art influenced the creative power of paintings like *Guernica* and how Mies van der Rohe's concern for classical form stood behind the design of the Barcelona Pavilion. Without a keen visual interest and an intense curiosity about the world he lives in, the designer will find himself digging deeper and deeper holes in all of the wrong places.

The design process 2

2. The design process

Graphic design is an umbrella phrase that covers a broad range of printed and projected images. Its three principal functions are to *persuade*, to *identify*, and to *inform*. Advertising is generally regarded as the medium of persuasion, although at times its purpose may be to identify or inform. Corporate identification, as the word implies, has identity as its central focus, but corporate literature will often inform and corporate advertising may have a persuasive purpose.

Most signage systems inform or identify, but it would be difficult to deny the persuasive intention of a stop sign. A package design may be involved in all three functions, and in most cases it adds a fourth—to protect. Most book design is concerned with information, but the book's jacket may be persuasive. This random selection of examples illustrates the difficulties we encounter when we attempt to divide graphic design into arbitrary categories.

The graphic design process—the search for visual concepts—has been compared to the running of a maze. In both cases the solution remains mysterious until the end of the exercise. From an established starting position, the designer works out a logical plan and follows it only to be turned back by the constraints encountered along the way. As in a maze, the designer continues the exploration through further applications of logic, some intuitive guesswork, and a certain amount of trial and error until the problem is solved.

The design process is both complex and highly personal. Even though the results may sometimes seem to be accidental, the quality of the solution will usually depend on the careful blending of the pragmatic and intuitive elements of the designer's

personality and a balance between intellectual and emotional **23**
responses. Some designers find their way to dynamic presen-
tation through a careful step-by-step process. Some often
seem able to form a fully realized concept in the inner recesses of
the mind before committing a mark to paper. Still others will work
their way through a growing tangle of idea sketches only to
unravel them into a final solution. No one method can generally
be considered as superior to the others. I have known designers
who worked in all of these ways to come up with equally original
and compelling results. Regardless of a designer's working
pattern, he will, in one way or another, follow a process that
closely parallels those outlined in the previous chapter.

Background

The opening phase of the design process begins with a study of
the information contained in the assignment. This seems fairly
obvious, but I continue to be amazed by the number of times
I have had to remind students or design assistants of the
specifications, after they have started to fill their pads with
misdirected sketches. When an assignment calls for a file size,
two-color folder and the designer is creating a sketch for a
four-color broadside, it is obvious that the instructions were
ignored or misunderstood.

Functions of graphic design: *The
pyramid at the right represents the three
principal functions of graphic design:*
identification, information, *and* persuasion.
*This is an oversimplification of what often
turns out to be a complex blend of functions
and objectives.*

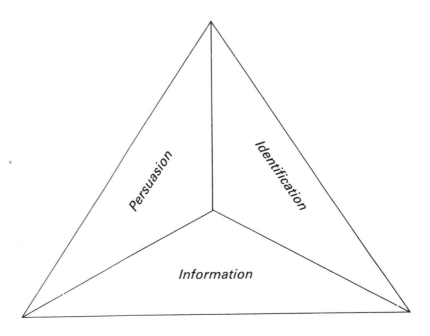

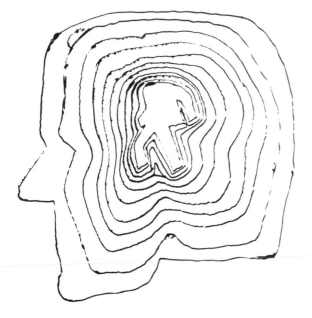

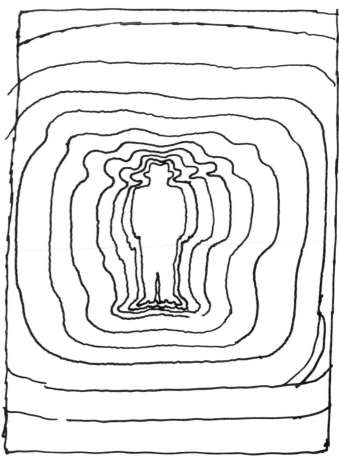

Nevertheless, it is a rare set of instructions that covers all the essential information for the completion of a project. Usually some additional research will be required. This may range from factual material in library files to a study of client intentions and customer motivation. In many cases a study of competitive influences may be important. Market research is a valid source, but sometimes a designer can learn more by a visit to the marketplace than he can from pages of statistics.

The amount of research required will vary with each individual project. In the designer's search for pertinent information, there is no substitute for asking the right questions when the assignment is received. Are the client's intentions clearly understood? Where does this project fit into a larger picture, and how does it relate to

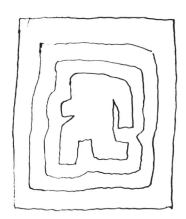

The design process: *Hans Hillmann's design for a poster promoting an Alec Guinness film called* The Man in the White Suit *illustrates three stages in concept development. Before starting work on the project the designer had to be aware of the long- and short-range exposure the poster would be subject to, the special nature of the film, and the place of the poster in the overall promotional pattern. The central idea of the concept was present in Hillmann's first sketch, but the relation of the inner and outer shapes was refined and simplified as the preliminary sketches progressed.*

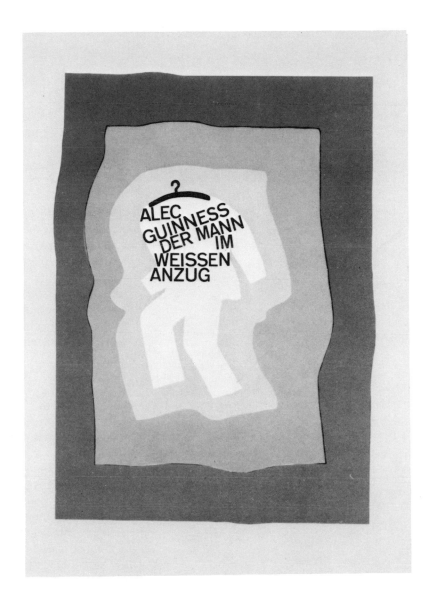

other communication objectives? Are the technical and budget constraints clearly understood, and how much flexibility is there in the publishing plans?

Constraints

One of the discoveries that a designer makes in the analytical phase of a design program is the nature of the constraints that may determine the direction of the creative effort. These include specifications of size, quantity, cost, and printing methods, and may even include some hidden legal requirements. On occasion the constraints may dictate the content, style, and technique of the illustrations. Sometimes these constraints are less rigid than is apparent, and it is up to the designer to determine how much latitude exists in developing the concept.

A perceptive designer will be aware that all constraints are not exactly what they seem. For example, our estimate of what the ultimate consumer expects or will accept and what the client wants can become phantom constraints that inhibit original ideas. Once, as the newly appointed head of a design department, I was warned by a subordinate that the director would never accept blue as a dominant color. Partly out of perversity and partly because blue seemed to be the right color for my concept, I submitted the design and it was accepted without a tremor. The director may well have explained a previous rejection by making a negative comment about blue, but chances are that he disliked the design for a different reason and merely singled out its color because he could neither comprehend nor explain his negative reaction.

The fact that constraints can sometimes make a real contribution should not be overlooked. It may seem paradoxical, but there are times when severe limitations that seem to deny all freedom of choice can have a positive effect on the process. The designer faced with these constraints is often forced to seek a fresh viewpoint and a simple design solution while avoiding the derivative or merely fashionable result that free options might have encouraged.

Nearly all teachers of graphic design will confirm that those assignments with tight constraints often generate the freshest and most varied solutions. On occasion I have set a project for my students in which they are denied any choice of size, material, typeface, or color. They are even given the sheets of colored paper and forced to paste rather than draw or paint the final dummy. Whether the project is for a package, book cover, record jacket, folder, or television storyboard, the results are invariably more creative and original than the solutions to similar problems that have greater freedom of choice.

The concept

When the research and analysis are completed, and sometimes even before, the designer's mind begins to explore the visual images that may point the way to the concept. This phase brings the deductive analysis into contact with the inductive level of the preconscious mind. It is at this point that a period of detachment (the period Freud refers to as *remission* and chapter one calls

incubation) takes place to make a break with our purely logical involvement with the problem. On some simple, straightforward projects, the designer may move directly from analysis to the logical development of a design solution, but even in these situations, most designers will weigh the relative value of his logical solution against the option of a more creative approach.

In the search for a creative solution, the detachment of the incubation phase may take many forms. The idea may surface when the designer is engaged in some unrelated activity, or he may make a conscious effort to set his thoughts in motion by sketching random solutions or even doodles. Some designers find it useful to return to work on a completely different project while waiting for ideas to start to percolate. Another way of encouraging the creative process is through exposure to a variety of visual stimuli or through a review of other design solutions to similar problems. It is not uncommon to use recent or old design annuals and publications for this purpose.

The advantages as well as the weaknesses of this approach to creative stimulation are fairly obvious. Because the printed work being reviewed relates to the problem a designer is attempting to solve, it can encourage thought processes and may even trigger an intuitive response leading to a fresh solution. On the other hand, an obvious danger exists that someone else's design may be appropriated and bent to solve a current problem. That is how these publications earned their reputation as "swipe-files."

Most designers use these sources at one time or another, but many prefer other stimuli for new design ideas. These sources can be as varied as nature and the landscape, people we meet and talk to, the fine arts and architecture, toys and games, artifacts, and all forms of man-made objects. In short, it can be any visual resource that will kindle the imagination and alert the senses without encouraging imitation.

There is one aspect of the creative process that has had very little scientific study, but for many designers it is quite real. In my own experience, in my observation of other designers at work, and in confirming conversations with several designers, I am convinced that there is a cyclical influence on idea production. While there are times when creative ideas are arrived at with an ease that makes the problem seem to solve itself, there are other times

when no amount of effort will produce more than a routine solution to the simplest problem. These apparent blocks to preconscious aid in the process cannot be overcome by rational means, and each designer must, in the end, work out his own solution. Sometimes detaching oneself from the problem and encouraging the incubation of ideas will work. Sometimes exposure to unrelated design objects, such as abstract art, will gradually set the creative force in motion. Sometimes going on to other things and almost forgetting the problem will help. Sitting and waiting for an idea to surface is only rarely effective, but time is often a necessity in restructuring the creative chain.

Verification Because design is a complex combination of many forces—the designer's taste, talent, knowledge, and experience balanced against the content and constraints of the assignment—and because the process is often intuitive, it requires constant evaluation. Each step in the appraisal may lead to modification of the original idea or, in some cases, a completely new concept may arise to supplant the one being evaluated.

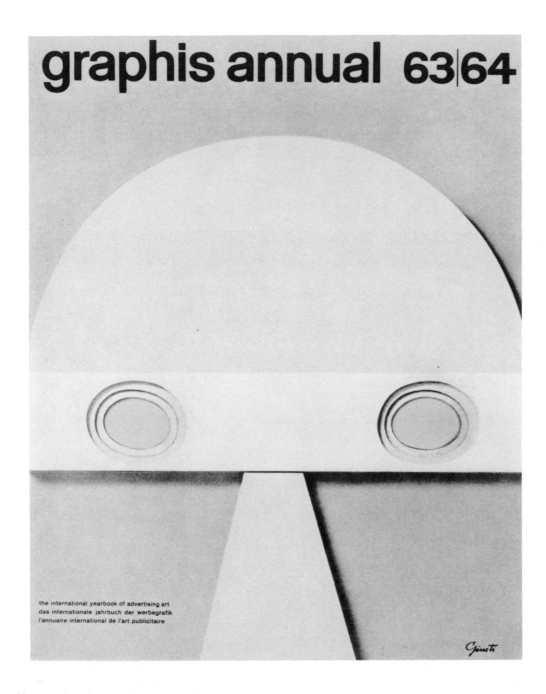

Precision in design: *George Giusti's first sketches and finished design for a* Graphis Annual *cover hint at the clarifying process in the development of an idea. Giusti says, "Once the idea sprouts in some hidden corner of my subconcious, logical considerations begin to give reality to the original idea and make it visible to others." The sureness of his approach and his meticulous attention to detail are clearly revealed in the sketches.*

Those early sketches that contain the seed of the idea are more important than many designers realize. No matter how small the scale or how crude the rendering, these first notations should visualize the basic concept as accurately as possible. They are designs, not scribbles. A review of some of the graphic sketches done by outstanding designers reveals a clarity and confidence that mark the designer's personal style and skill (see pages 25 and 28). It is also important that a designer think through the details of his concept at an early stage. Color and typography should be carefully considered and noted. If a concept is incomplete in the thinking stage, it may fall apart completely when it is worked up into a more comprehensive rendering.

In evaluating a concept, space and time can assist us in making

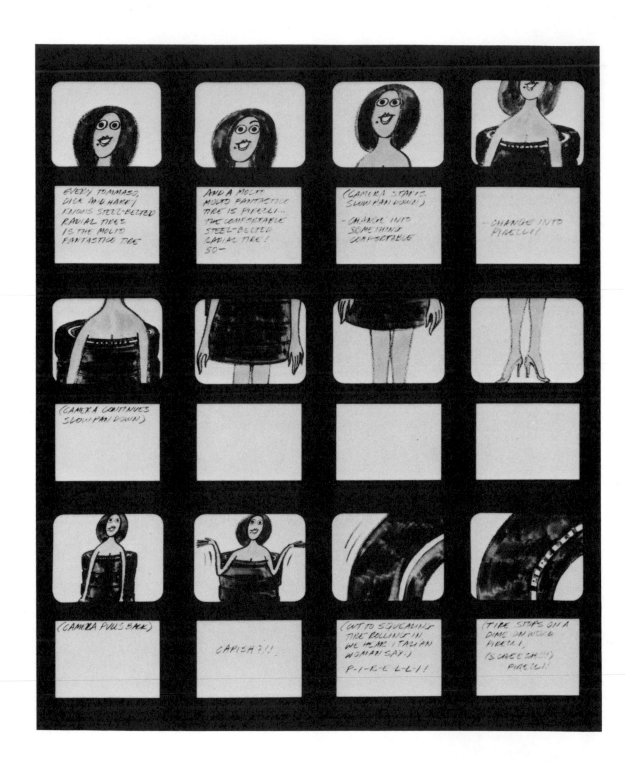

Storyboard: *George Lois puts concept ahead of technique and cinematography in television commercials, and his quick sketches bear out his concern with clarity and continuity. He says, "When I draw a storyboard I'm laying plans to stop a guy in his tracks as he heads for the kitchen to get another beer." This storyboard for Pirelli Tires is based on the line, "Change into something comfortable."*

our value judgements. Backing away from a design may give another view. Sometimes a design that seems to work in the thumbnail size will not hold up when it is translated to its final scale. The sketch that seemed adequate when we put it down may be less successful when it is appraised in the cold light of tomorrow's dawn. In the verification phase, as in the creative phase, a certain amount of detachment is valuable and helps the designer to take a fresh look at the work.

One of the most difficult decisions a designer makes is the selection of the final idea from collected sketches produced during the creative process. There are even times when none of the sketches represent the ideal solution the designer had hoped for. In these circumstances it is often better to keep to the schedule and work up the best available idea rather than to sit and wait for another inspiration. There is even a possibility that a better idea will surface while the sketch is being translated into a finished rendering. Difficult as the selection process is, it must be faced and not passed on to others—especially the client.

Working methods

Over forty years ago Pablo Picasso was quoted in an issue of *Cahiers d'Art* as saying, "It would be interesting to record photographically, not the steps in making a painting, but its metamorphoses. One might be able to see by what path a mind finds its way to the crystallization of an idea." In discussing his own working methods he went on to say, "The picture is not always thought out and determined before painting, instead while it is being made it follows the mobility of thought."

Picasso never solved the problem of recording the metamorphoses of an idea, but a few years later he became involved in the making of a major film about his working methods. The film was called *Le Mystère Picasso*, and it was directed and produced by the noted filmmaker Georges-Henri Clouzot.

In the early part of the film Picasso demonstrated his incredible skill as a draughtsman by creating a series of drawings and paintings that were photographed from behind the working surface as he worked. Images took form and were changed and modified with miraculous speed and dexterity. At this point the viewer has the impression of an artist who could do nothing wrong.

The second half of the film documented the creation of a major painting through a series of stop-action exposures. The painting was five feet (150 cm) wide, and its subject was an allegorical beach scene called "La Garoupe." The work began with a few quickly brushed lines that divided the space and directed the action of the painting. As the painting progressed and one idea superseded another and figures were added only to be modified and finally obliterated for other ideas, frustration began to take over. Picasso became increasingly disappointed with the way the painting was going and finally spoke the only words recorded on the sound track of the film:

"Ca va ma!—très mal" (it's going wrong all wrong).

His imagination and enthusiasm had propelled him beyond a score of stages that lesser artists would have settled for to what seemed like a point of no return. With a swab of turpentine he erased large areas of his work and began again.

This incident in the working life of a creative genius reminds us that in the creative process tough decisions must be made and the resulting difficulties can even frustrate a master. The incident also suggests the importance of retaining early sketches in our own quest for creative solutions. Sometimes a designer has to turn back in order to go forward. The seeds of an idea often turn up in his very first sketches.

In the final chapter of this book several outstanding graphic designers discuss their search for an idea. In the process, they shed quite a bit of light on their approach to a problem and their own working methods. From these examples it is clear that these working methods will vary widely between designer and designer and from problem to problem.

The precise environment in which a designer works seems to have minimal effect on the direction or quality of his efforts. Paul Rand operates in a studio environment that might best be described as well-organized chaos. George Lois insists on the ultimate in pristine order. He has purged his office of all visual images. There are no paintings or graphic designs—his own or anyone else's. There is only a blank wall to stare at, and the specific work in progress on his black marble drawing stand is the only visible element. When Milton Glaser's career was at its busiest, when he was design director for *New York* magazine and

M onroe? Just a slob, really: an untidy divinity—in the sense that a banana split or cherry jubilee is untidy but divine.

Her slippery lips, her overspilling blondness and sliding brassiere straps, the rhythmic writhing of restless poundage wriggling for room inside roomless décolletage—such are her emblems, those caricaturable flauntings that, one would have supposed, made her at once world-recognizable. However, in what is said to be real life, the Monroe is not easily identified. She maneuvers New York streets unmolested by stares, signals for taxis that do not stop, is served orange juice at a sidewalk Neslick's by an attendant unaware that the customer is the subject of some of his more ambitious ambitions; indeed, more often than otherwise one has to be told Monroe is Monroe, for she seems, casually glanced, merely another specimen of the American geisha, the expense-account darling, those cabaret-cuties whose careers progress from tinted hair at twelve to a confiscated husband or three at twenty. But true to type as aspects of the Monroe are, she is not genuinely of the genre, she is too untough to be, moreover she is capable of sensitive concentration always the secret of making any talent work, which hers does: the character she performs, a waif-figure of saucy pathos, is sound and convincing charm: very understandably so, since there is small difference between her screen image and the impression she

Trial-and-error: *Alexey Brodovitch's designs were often arrived at by exploration and even trial-and error, but the results were always outstanding layouts like these from Richard Avedon's book Observations. Brodovitch's designs were precise orchestrations of scale, contrast, and form.*

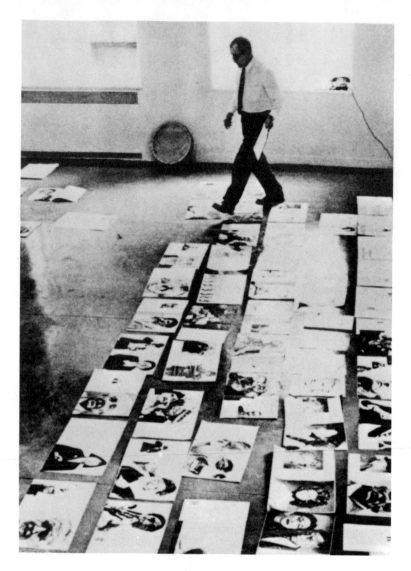

Continuity and harmony: *When Alexey Brodovitch had completed the spread layouts for a book or magazine, he would spread them out on the floor and march around them, arranging and rearranging them until he was satisfied with the visual continuity. Here with layouts from* Observations, *he is photographed by Richard Avedon in the act of creation.*

creating some of his most exciting posters, he had no office of his own. He worked at a large drawing board in the cluttered bullpen of Push Pin Studios. It is obvious that environment is a matter of personal choice and not the secret of creative ideas.

One designer who is not included in chapter six on Connections, but who is worth our attention, is the late Alexey Brodovitch. A Russian-born designer who came to America in 1930, Brodovitch exerted a powerful influence on several generations of graphic designers. He was art director of *Harper's Bazaar*, and his teaching, first in Philadelphia and later in New York, brought him into contact with students who were to become leading photographers and designers.

The way that Brodovitch worked comes to us in fragments. He loved white paper. He could be swift and sure when the pressure was on, but he was probably happiest when he had the time to shuffle through quantities of photostats in many different sizes. Like a conductor working out the orchestration of a complex score, he would select, reject, crop, position, and size images until he was convinced that he had arrived at the right solution.

Sometimes he arranged the images under a spread-size sheet of glass so he could study the relationship of the pictures to his precious white space.

This combination of exploration and decisive action continued until the collected layouts of the magazine spreads were placed in a casual sequence on the floor of the editor's office. There, under his sharp and discerning eye, the layouts were arranged and rearranged until he was satisfied with the issue's visual content (see page 34).

Scale

Most graphic designers render their first idea sketches in a size considerably smaller than the final design. Aside from the obvious saving in paper, designers are often able to develop a fine sense of proportion working on this reduced scale. In fact, they will sometimes encounter difficulty in translating the proportion to the final size. In this circumstance it is often desirable to turn to direct enlargement of the thumbnail sketch to preserve its sense of proportion. At a time when I was expected to turn out a large number of full-page newspaper advertisements, I worked from small sketches which I enlarged photographically and to which I merely added the type specifications before they went to the typesetter.

On the other hand, there are many designers such as Brodovitch who prefer to do their creative thinking in true scale, and most designers will use both approaches. Working in the actual size can be useful when the designer is working with photographs or where he is planning his design to fit a predetermined grid.

Technique

Technique is largely a matter of personal style, but the ability to render visuals quickly and concisely is one of the designer's most critical skills. In recent years the felt-tip pen and colored markers have replaced pencils and paints as the sketching medium, just as technical pens have replaced ruling pens in most finished artwork. The advantage of the marker over the pencil is that its black line makes a more positive statement, but the change of medium has not altered the dominant role of the sketch as a means of recording ideas. These renderings provide a basis for early evaluation of concepts and become the means of communicating those ideas to others. Many concepts receive

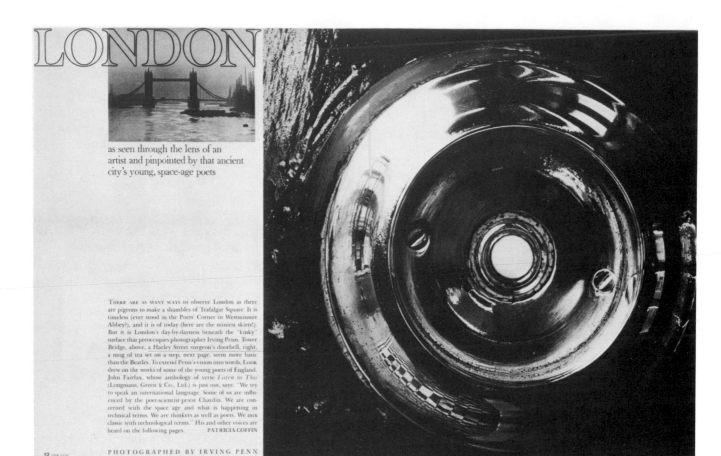

LONDON

as seen through the lens of an artist and pinpointed by that ancient city's young, space-age poets

THERE ARE AS MANY WAYS to observe London as there are pigeons to make a shambles of Trafalgar Square. It is timeless (ever stood in the Poets' Corner in Westminster Abbey?), and it is of today (here are the miniest skirts!). But it is London's day-by-dayness beneath the "kinky" surface that preoccupies photographer Irving Penn. Tower Bridge, above, a Harley Street surgeon's doorbell, right, a mug of tea set on a step, next page, seem more basic than the Beatles. To extend Penn's vision into words, Look drew on the works of some of the young poets of England. John Fairfax, whose anthology of verse *Listen to This* (Longmans, Green & Co., Ltd.) is just out, says: "We try to speak an international language. Some of us are influenced by the poet-scientist-priest Chardin. We are concerned with the space age and what is happening in technical terms. We are thinkers as well as poets. We mix classic with technological terms." His and other voices are heard on the following pages. PATRICIA COFFIN

PHOTOGRAPHED BY IRVING PENN

Design scale: *My first sketches for Look magazine layouts were often rendered in a very small size. This sketch for a 21-inch (532 mm) spread was only 3 inches (76 mm) wide, but it gave a reasonably accurate projection of the finished design and included all of the essential details of typographic finish.*

their first exposure as a croquis rendered on the back of an **37** envelope, the margin of a menu, or the white space of someone else's advertisement.

While drawings are the principal means by which creative ideas take form, they are not the only design vehicle. When Henri Matisse switched from painting to assembled cutouts, he opened a new channel to his creative power. Josef Albers, a great graphic design teacher, first at the Bauhaus and later at Yale, emphasized the dynamics of designing with colored paper. The photomontages of the Dadaists and Constructivists provided additional evidence of the importance of cutout and assembly. Sometimes when ideas fail to surface through sketches, a designer may encourage a breakthrough by cutting and arranging his images. In any event, it is a worthwhile exercise that may expand a designer's perception.

Chance

Regardless of their working methods or design philosophy, most designers will admit to having arrived at some of their best concepts through pure chance. The accidental effect of an image viewed through a discarded cutout, an image seen in juxtaposition with another visual element in the reflection of a window, or an accidental photographic exposure can sometimes provide the stimulation a designer needs to arrive at an original idea. Some important graphic concepts have been inspired by printers strike sheets, where unrelated images are overprinted on a sheet to test register or makeup.

There are two levels of chance that can influence concept formation. One is the pure accident of vision and events and the other is the controlled accident, where the designer sets the stage for chance. An advantage of working with collage or cutouts is the opportunity that these techniques offer to produce and take advantage of the accidental effect. Both random and controlled chance can be effective if the designer is alert.

Summary

The obvious starting point for a graphic design is the white rectangle of paper on the designer's drawing stand. But, in most cases, before he reaches for his pencil or felt-tip marker, a great deal of study will already have taken place.

Even before he begins his analysis of the problem, the astute designer will absorb all the pertinent information contained in the assignment. He will know how to augment this material with his own research, and he will know what questions to ask to fill the remaining gaps. He will think about the needs and motivations of the ultimate viewer as well as the stated and implied objectives of his client.

For most designers the analysis will continue into the more creative phase and serve as a bridge between the deductive and inductive thought process. How the inspiration is arrived at remains somewhat mysterious. For some designers the idea will appear as a dimly formed image in the mind before a single sketch has been made, but for most the idea will develop out of a blur of unrelated scribbles, trial drawings, or assembled fragments. Most often a trial-and-error collection will be the starting point for the evaluation process.

The ways in which ideas will make themselves manifest will vary from time to time, from project to project, and from designer to designer. The stimulation may come from staring at a blank wall or out of a window. It may come from reviewing other related or even unrelated design solutions on the pages of books or magazines. It may come by pure chance, or the idea may hatch in the inner recesses of his mind while he is drinking, engaged in conversation, or brushing his teeth.

When a designer begins to transfer the ideas to paper by sketching or assembly, there should be an awareness that the thumbnail rendering is a visual for a printed or projected image and not just a casual doodle. The designer should already be thinking in terms of color and typographic detail. It's absurd for a designer to end up rendering a full-size poster in its final form and then wondering where the type should go.

Verification of the concept and the process of evaluation often begins before the design is fully visualized and set to paper. In most cases it will continue throughout the exercise—the thumbnails, the comprehensive rendering for presentation, photography, finished artwork, proofs or answer prints, the final printed or projected image, and, if possible, the measured response of the audience. Design is a decision-making process, and the ability of the designer to make sound value judgements will have a bearing on the quality and effectiveness of a concept.

3

Word and image

3. Word and image

From the earliest paleolithic cave painting to the latest laminated record jackets, visual images have communicated ideas, and it was pictures that provided the glyphs for the first written records. We learn language by applying words to visual experiences, and we create visual images to illustrate verbal ideas. This interaction of word and image is the background for contemporary communication.

The comparatively new art of advertising was dominated by verbal thinking until the 1940s. The accepted procedure was for the copywriter to create the headline, supporting text, and nearly inevitable coupon of an advertisement in the splendid isolation of his office. It was then conveyed to another part of the building where the art department was located. The art director then produced the layout and illustrations in a manner somewhat akin to a custom tailor fitting a suit of clothes.

When modern designers and creative art directors with ideas of their own began to exert their influence on advertising, the balance began to shift away from purely verbal concepts toward a more unified word and image presentation. Today the term advertising concept has come to mean an overall theme derived from the unique advantages of the product or service involved. In most cases the concept is mutually arrived at by the writer and designer working together as a creative team. They often combine forces from the analysis of a problem to its ultimate solution, and it is not unusual for the copywriter to contribute visual thinking and for the art director to supply some of the words.

Perhaps the principal architect of the concept approach in advertising was William Bernbach. In 1940, after completing his

41

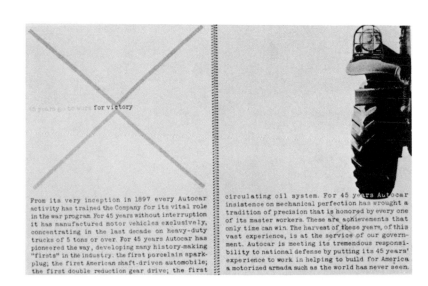

From its very inception in 1897 every Autocar activity has trained the Company for its vital role in the war program. For 45 years without interruption it has manufactured motor vehicles exclusively, concentrating in the last decade on heavy-duty trucks of 5 tons or over. For 45 years Autocar has pioneered the way, developing many history-making "firsts" in the industry: the first porcelain spark-plug; the first American shaft-driven automobile; the first double reduction gear drive; the first

circulating oil system. For 45 years Autocar insistence on mechanical perfection has wrought a tradition of precision that is honored by every one of its master workers. These are achievements that only time can win. The harvest of these years, of this vast experience, is at the service of our government. Autocar is meeting its tremendous responsibility to national defense by putting its 45 years' experience to work in helping to build for America a motorized armada such as the world has never seen.

This historic wartime advertising brochure for Autocar was designed by Paul Rand, written by William Bernbach, and photographed by Lyonel Feininger for the William Weintraub Agency, an early and impressive creative team.

publicity work on the New York World's Fair and some years before he and his partners set up Doyle Dane Bernbach, he became a copywriter with the William Weintraub advertising agency where Paul Rand was the art director. Bill Bernbach speaks of his meeting with Paul Rand as the beginning of "a tremendous interplay between two disciplines," and Paul Rand remembers it as his "first meeting with a copywriter who understood visual ideas . . . who didn't come in with a yellow copy pad and a preconceived notion of what the advertisement should look like."

So much happened to advertising in the 1940s that it wouldn't be quite accurate to say that it all began here, but looking back on this eventful meeting, it is clear that the isolation of copy and art functions was coming to an end. Under Bill Bernbach's influence, the concept approach gradually emerged. Its first clear manifestation was in an advertising campaign for a then little-known New York department store, Ohrbach's. At that time Bernbach was with Grey Advertising Agency, and the campaign he developed departed from the product promotion and merchandising that characterized most department store advertising. Instead, he concentrated on an overall concept based on the unique value of shopping at Ohrbach's (see page 42). This image building concept has continued for over thirty years, and the advertisements have been designed by a

42 **Classic:** *This example from the landmark series of advertisements for Ohrbach's was a forerunner of the concept approach. It was designed by Paul Rand and written by William Bernbach in 1948 for the Grey Advertising Agency.*

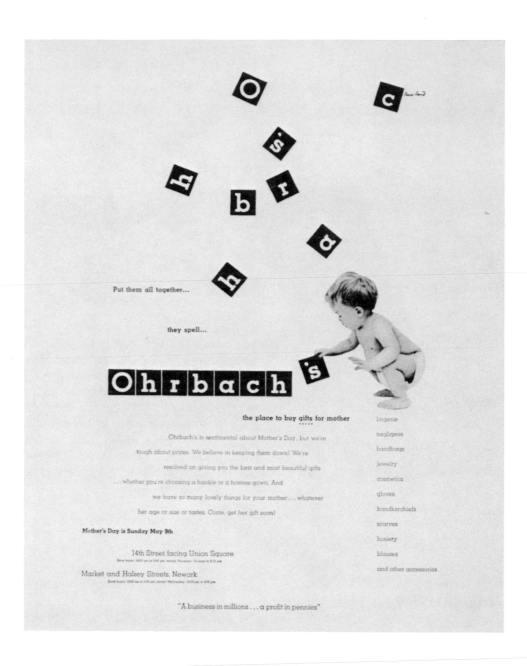

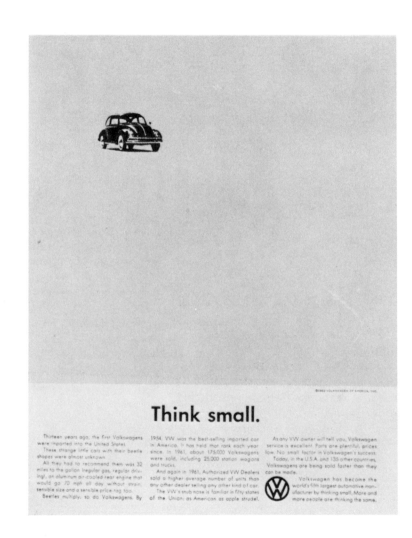

The concept: *By 1959 the concept approach to advertising was fully developed. The "Think Small" advertisement for Volkswagen is generally conceded to be an almost perfect example of the technique. The concept was created by Helmut Krone, art director, and Julian Koenig, copywriter.*

distinguished group of art directors including Paul Rand, Bob Gage, and Helmut Krone.

Doyle Dane Bernbach was established as an advertising agency in 1948, and the process of developing the concept approach continued. It probably reached its most definitive form in the campaign for Volkswagen automobiles that began in 1959. This car's small beetlelike profile, which suited continental economy-minded tastes, seemed hopelessly inappropriate for American super-highways. The landmark advertising campaign

developed by Doyle Dane Bernbach for Volkswagen overcame this resistance and changed the taste and attitudes of many American car buyers decades before fuel shortages.

By the time they undertook the Volkswagen challenge, the agency had grown to include several creative teams. The first VW advertisements were designed by Helmut Krone with words by Julian Koenig and a powerful assist by Bill Bernbach. In the early sixties Robert Levenson became creative director on the account and later Vice-Chairman of the agency. In 1976 he wrote in *Graphis* magazine:

" 'Think small' (see page 43) was not the first VW ad, but it summed up the attitude that turned the automotive world upside down. . . . It wasn't easy and it didn't happen overnight. The

The other side: *In general, negative ideas are avoided in advertising concepts, but this Volkswagen advertisement took advantage of the shock value of its headline—the ultimate derogatory term for an automobile—and twisted it to the client's advantage. As writer Bob Levenson said, "It's not easy for a client to run an ad like* Lemon*." The designer and art director was Helmut Krone.*

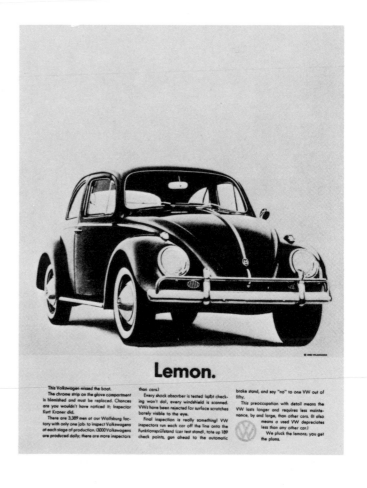

Continuity: *For over twenty years at Doyle Dane Bernbach the VW campaign has been a model of consistency and continuity. When a new line of front-wheel-drive vehicles replaced the beetle in the seventies, Bob Levenson and Bert Steinhauser revised the format but retained the continuity with persuasive concepts and simple typography.*

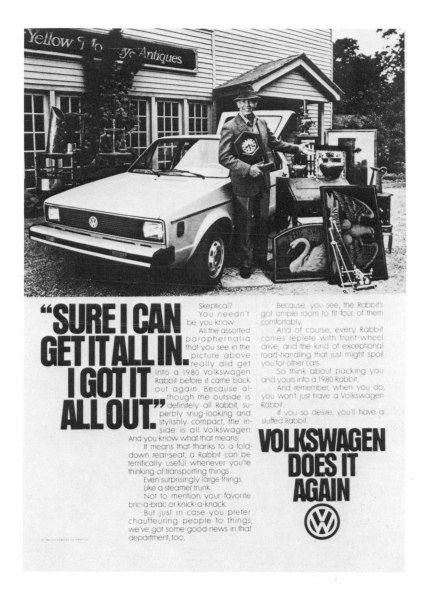

"SURE I CAN GET IT ALL IN. I GOT IT ALL OUT."

Skeptical? You needn't be, you know.

All the assorted paraphernalia that you see in the picture above really did get into a 1980 Volkswagen Rabbit before it came back out again. Because although the outside is definitely all Rabbit, superbly snug-looking and stylishly compact, the inside is all Volkswagen. And you know what that means.

It means that thanks to a fold-down rear-seat, a Rabbit can be terrifically useful whenever you're thinking of transporting things.

Even surprisingly large things. Like a steamer trunk.

Not to mention your favorite bric-a-brac or knick-a-knack.

But just in case you prefer chauffeuring people to things, we've got some good news in that department, too.

Because, you see, the Rabbit's got ample room to fit four of them comfortably.

And of course, every Rabbit comes replete with front-wheel drive, and the kind of exceptional road-handling that just might spoil you for other cars.

So think about packing you and yours into a 1980 Rabbit.

And remember, when you do, you won't just have a Volkswagen Rabbit.

If you so desire, you'll have a stuffed Rabbit.

VOLKSWAGEN DOES IT AGAIN

advertising budget was small and every ad had to do the work of a whole campaign. . . . It also took guts. It's not easy for a client to run an ad like 'Lemon' " (see page 44).

Because the Volkswagen campaign included not one but a variety of conceptual approaches, several examples will appear as illustrations in this chapter. A study of these advertisements will also demonstrate in a dramatic way the importance of continuity and consistency as a design strategy. This held true when the Beetle was replaced by a line of front-wheel-drive vehicles in the 1970s.

The creative team

A close working relationship between art and copy is central to the concept approach to advertising. The creative team of copywriter and art director work together to formulate a theme for the campaign and proceed to originate the ideas for the individual advertisements. This attitude toward advertising places great emphasis on creative strategy and creative thinking

46

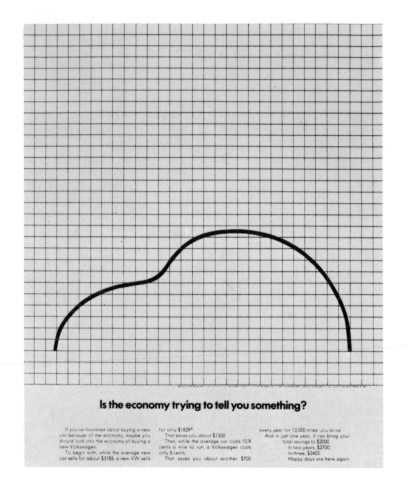

Is the economy trying to tell you something?

If you've hesitated about buying a new car because of the economy, maybe you should look into the economy of buying a new Volkswagen.

To begin with, while the average new car sells for about $3185, a new VW sells for only $1839*.

That saves you about $1300.

Then, while the average car costs 10.9 cents a mile to run, a Volkswagen costs only 5 cents.

That saves you about another $700 every year for 12,000 miles you drive.

And in just one year, it can bring your total savings to $2000.

In two years, $2700.

In three, $3400.

Happy days are here again.

Recognition: *From the beginning, in the late 1950s, product recognition was a key part of the Volkswagen advertising. Aided by the car's unique appearance, the Doyle Dane Bernbach creative teams were able to bring this identity across in several ways. In this ad the form of the beetle was suggested by a flow chart showing an economic downturn. Designer: Ted Shane, Copywriter: Tom Yobaggy.*

in the planning phases. The team becomes more closely identified with the product or service being promoted and plays a more significant role in decision making.

In the 1950s some advertising agencies misread the function and advantages of the creative team and attempted to extend the two-is-better-than-one philosophy into even larger groupings. This procedure was labelled "brainstorming," and it was supposed to compound the creative opportunities. These creative conglomerates occasionally came up with a good idea, but their output often lacked the product understanding or continuity of the more specialized creative team. For the most part "brainstorming" provided confirmation for the ancient legend that "a camel is a horse invented by a committee."

Continuity

A pioneer advertising copywriter once said, "only when the advertiser becomes bored to death with his ads does the public begin to catch on." Today, one doesn't have to look far to find examples of ideas that have been abandoned long before there is a chance of any real response.

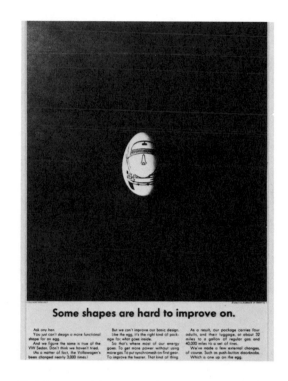

Symbol: *In this 1963 advertisement, the egg is used to suggest the functional form of the Volkswagen Beetle. In addition to increasing recognition value, the advertisement made a point about the unchanging appearance of the car. The designer was Paul Wollman, and D. Herzbrun wrote the copy.*

But the need for more than mere repetition was emphasized by Bill Bernbach when he said: "There are two ways you can make a product's advantages memorable. You can say it a thousand times until it finally sinks in. Or you can say it ten times in such a fresh way that people can't forget you."

Continuity in an advertising campaign is obviously aided by consistent visual treatment of the concept. From the start, the designer's concern is to establish a format that will not only provide long-range identity but that will also remain flexible enough to accept the new ideas and modifications that are inevitable as the campaign develops. The basic format of the Volkswagen advertisements was disarmingly simple. It consisted of a modular division of the rectangular space with the illustration occupying the top four-fifths of the space; a centered bold headline appeared below, followed by 80 to 150 words of texts. When the format was revised for the new models, more emphasis was put on the copy with larger and bolder headlines arranged asymmetrically and with a new bold concluding line, "Volkswagen does it again," to make the identification more positive and to provide continuity with previous ads.

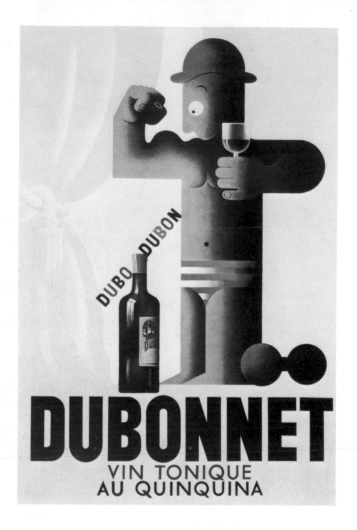

48

Classic symbol: *This French poster for Dubonnet by A. M. Cassandre is one of a series in which the figure of the "little man" was used to extol the virtues and underscore the identity of this well known French drink.*

The typographic style of both the new and old campaigns was also consistent and was based on ease of reading. The sans serif typeface (Futura in the old, Avant Garde in the new) was generous in size and the lines were relatively short. Paragraph breaks were plentiful and indentations were ample. When paragraphs ended with "widows," they were left short—a detail on which most typographic purists would frown.

Recognition

One of the earliest and most enduring advertising strategies is the simple one of persuading people to recognize a brand. When consumers are given a choice of packaged goods, they are most inclined to select the ones they are familiar with through either use or exposure. A new product needs to make itself known by its name, its trademark, its form, and its function, or any combination of these.

One of the principal objectives of any advertising campaign is the creation of this product familiarity. The Volkswagen campaign was a classic example. The point has already been made that from the beginning VW concentrated on showing how the car looked, and it is a tribute to that strategy that ten years later it was

Modern symbol: *When David Ogilvy of Ogilvy & Mather came up with the concept of the eye patch as an identifying symbol for Hathaway shirts in 1950, he was following the same tradition as Cassandre in the Dubonnet series. The Art Director was Vincent de Giacoma, the Photographer was Paul Radkai.*

possible to identify the car when its contours were suggested by the simple curved line of a flow chart (see page 46).

Product identification is one of the best ways to introduce a new product or one that is not well known. It is also appropriate for a product that has been restyled, and it is sometimes the only valid approach for those products that are prevented from promoting their virtues for one reason or another. Cigarettes with their legal and ethical restrictions are a case in point.

One of the oldest methods of establishing recognition is through the use of signs and symbols. The use of the cross as a visual sign predated Christianity by several centuries. Some symbols take on different connotations through use. The red circle of the Japanese battle flag can also signify STOP or identify a skating rink. The swastika had a more pleasant connotation in some earlier cultures than when it became the German symbol for the

50 **Demonstration:** *To illustrate the ruggedness of American Tourister luggage, this Doyle Dane Bernbach commercial photographed a case in slow motion as it fell from a helicopter and survived. The art director was Roy Grace, the copywriter was Marcia Bell Grace.*

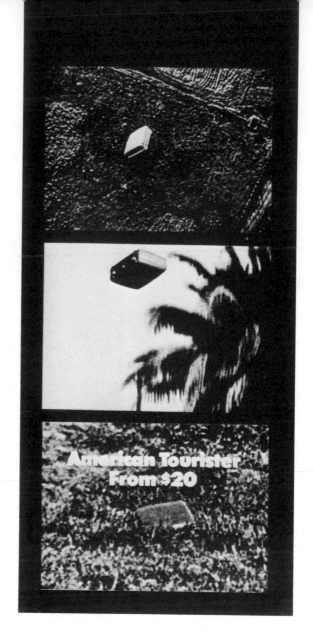

Nazi party. Even the cross has other uses and meanings—the Red Cross, the Swiss flag, and the mathematical plus sign.

In advertising, symbols function in two major areas. The first and most common is the trademark. While trademarks can be useful in the recognition strategy of advertising and are sometimes an absolute requirement, there are times when they are best left on the letterhead or the annual report.

Symbols can be valuable in advertising concepts when they are not trademarks. A classic example can be found in the posters by A. M. Cassandre for Dubonnet. He developed a drinking figure that for many years served as an identification for this brand (see page 48). When David Ogilvy of Ogilvy and Mather decided to put an eye patch on the model in the Hathaway shirt advertisements he was creating a symbol (see page 49). Later he persuaded Commander Whitehead, the director of Schweppes, to pose in his advertisements and TV commercials and become

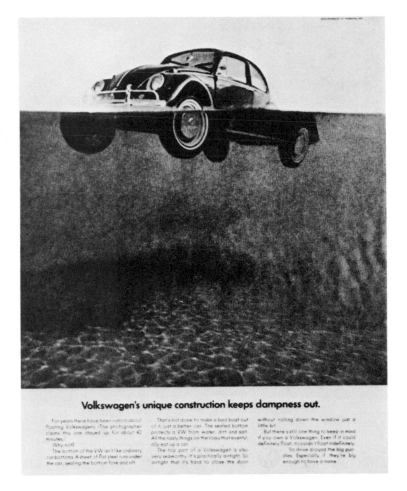

Volkswagen's unique construction keeps dampness out.

For years there have been rumors about floating Volkswagens. The photographer claims this one stayed up for about 42 minutes.

Why not?

The bottom of the VW isn't like ordinary car bottoms. A sheet of flat steel runs under the car, sealing the bottom fore and aft.

That's not done to make a bad boat out of it, just a better car. The sealed bottom protects a VW from water, dirt and salt. All the nasty things on the road that eventually eat up a car.

The top part of a Volkswagen is also very seaworthy. It's practically airtight. So airtight that it's hard to close the door

without rolling down the window just a little bit.

But there's still one thing to keep in mind if you own a Volkswagen. Even if it could definitely float, it couldn't float indefinitely.

So drive around the big puddles. Especially if they're big enough to have a name.

Demonstration: *This VW advertisement features a floating car to show that "Volkswagen's unique construction keeps dampness out." But it warns readers that "If it could definitely float it couldn't float indefinitely." The design was by George Gomes, copy by Charles Ewell.*

its symbol. More recently Scali McCabe and Sloves built a successful campaign around Frank Perdue, a tough but convincing company head. With imagination it is possible to create symbols from all kinds of elements.

Demonstration

Where it is possible to go beyond mere brand identification and promote the advantages of a product, one of the most favored methods is demonstration. When Doyle Dane Bernbach produced a television commercial that showed a Volkswagen fighting its way through a raging blizzard to its objective, which was superbly identified in one cryptic line, "Did you ever wonder how the man who drives the snowplow gets to the snowplow," it was a convincing demonstration of the car's traction.

In another campaign for American Tourister its ruggedness and durability were demonstrated when it was shown being thrown out of an airplane (see page 50) or stepped on by an elephant.

52

Avis is only No.2 in rent a cars. So why go with us?

We try harder.
(When you're not the biggest, you have to.)
We just can't afford dirty ash-trays. Or half-empty gas tanks. Or worn wipers. Or unwashed cars. Or low tires. Or anything less than seat-adjusters that adjust. Heaters that heat. Defrost-ers that defrost.
Obviously, the thing we try hardest for is just to be nice. To start you out right with a new car, like a lively, super-torque Ford, and a pleasant smile. To let you know, say, where you can get a good, hot pastrami sandwich in Duluth.
Why?
Because we can't afford to take you for granted.
Go with us next time.
The line at our counter is shorter.

Declarative: *The advertisement that set the theme for the Avis campaign turned the overworked "Number one" boast to its advantage and made a virtue of being only number two. The concept was developed by art director Helmut Krone, and the copywriter was Paula Green.*

Most concepts work well in both printed and broadcast images, but some concepts fit one medium better than another. Television's combination of audio-visual presentation and moving images has some obvious advantages in the demonstration of many product functions. On the other hand, product identification can sometimes be better served by the printed page with images that can be retained and referred to.

Sometimes a demonstration can be twisted to mean something other than what it seems to show. For example, when Volkswagen ran an advertisement showing one of its cars floating in water (see page 51), the point was the car's uniquely sealed under-construction and not that the car was a sensible substitute for a boat.

Declaration

Declarative or self-assertive advertising that points out the virtues of a product continues to be a widely used strategy in spite of the obvious credibility gap. In the early days of advertising, it was common to use images of the founder of a company or factory as symbols of respectability. Later the trend was toward product illustration, often accompanied by outlandish claims for the product's ability to improve a buyer's health, attractiveness, or well-being. Today fair-trade regulations and a newly discovered code of ethics have gradually eliminated some of the excesses.

As markets became more competitive, the advertising emphasis

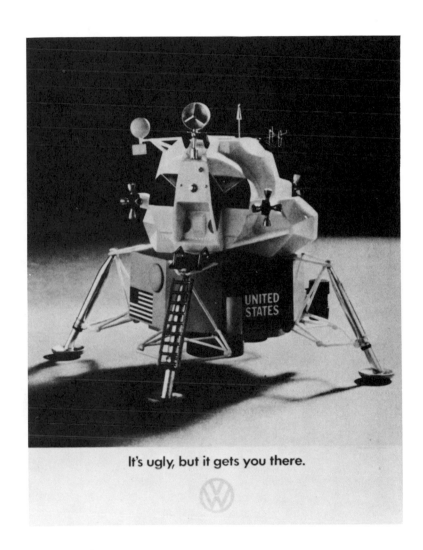

It's ugly, but it gets you there.

Inferential: *By the time this Volkswagen advertisement appeared in 1969, only a trademark was needed to identify the car from which it was possible to infer its quality. The art director was Jim Brown and the copywriter was Larry Levenson.*

switched to promoting product advantages and to "the unique selling proposition." No one knows for sure who first referred to a company or product as "number 1," but this was destined to be one of the most overworked phrases in the advertising lexicon. Some justification can be found for this assertive and boastful form of persuasion in its implication that a buyer can be stimulated or persuaded to follow-the-leader. An unsure buyer can often be reassured when he knows that his decision puts him safely in agreement with the majority of his peers. The risk in this strategy lies in the already mentioned lack of credibility and in the inevitable dullness that this extravagant breast-beating leads to.

54

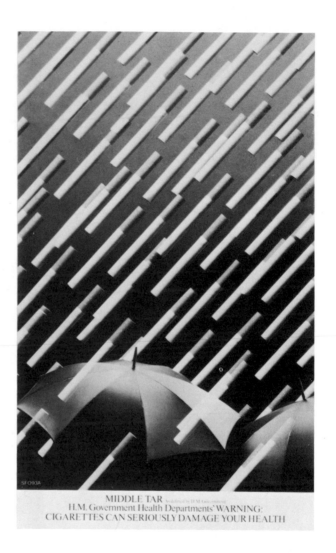

MIDDLE TAR As defined by H.M. Government
H.M. Government Health Departments' WARNING:
CIGARETTES CAN SERIOUSLY DAMAGE YOUR HEALTH

Understatement: *Benson & Hedges cigarettes have been advertising their "gold" brand in England in a campaign which deliberately underplays the brand name and often conceals the pack. In this advertisement, the only suggestion of brand identity is the gold color on the umbrellas.*

Despite the obvious disadvantages of this type of advertising, one of the most unusual and successful variations on the "number 1" theme was the campaign prepared by Doyle Dane Bernbach for Avis. When the agency took over the account, the company was clearly in second place to Hertz in the car rental business. By using the headline: "Avis is only No. 2," they inferred that you could get better attention, better service, and a better deal by driving an Avis car. With this unique strategy they elevated the challenger role to a new level of importance (see page 52).

Inference

There are times when it is better to infer the advantages of a product than state them directly. The "Think small" advertisement might have had a headline reading, "When you think of cars, think

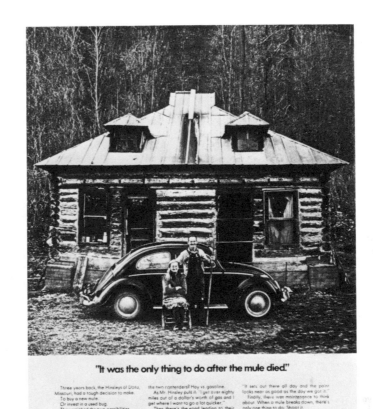

"It was the only thing to do after the mule died."

Three years back, the Hinsleys of Uora, Missouri, had a tough decision to make. To buy a new mule. Or invest in a used bug. They weighed the two possibilities. First there was the problem of the bitter Ozark winters. Tough on a warm-blooded mule. Not so tough on an air-cooled VW. Then, what about the eating habits of the two contenders? Hay vs. gasoline. As Mr. Hinsley puts it, "I get over eighty miles out of a dollar's worth of gas and I get where I want to go a lot quicker." Then there's the road leading to their cabin. Many a mule pulling a wagon and many a conventional automobile has spent many an hour stuck in the mud. Also, a mule needs a barn. A bug doesn't. It sits out there all day and the paint looks near as good as the day we got it. Finally, there was maintenance to think about. When a mule breaks down, there's only one thing to do: Shoot it. But if and when their bug breaks down, the Hinsleys have a Volkswagen dealer only two gallons away.

Endorsement: *This is about as close as the Volkswagen campaign ever came to product endorsement, as a Missouri couple praise the ruggedness, durability, and economy of owning a VW instead of a mule. The designer was Robert Kuperman, the writer John Noble.*

of small cars." It might have been more explicit, but it certainly wouldn't have been as effective. Later Volkswagen pushed this approach even further when it ran an advertisement featuring a moon module. The headline "It's ugly, but it gets you there" and a VW trademark made even the connection with the car inferential (see page 53).

Inference has two specific advantages in advertising: by avoiding the direct, boastful statement, credibility is gained, and by allowing the reader to participate in the process, the chances of the message being remembered are dramatically increased.

Endorsement Advertisers have long recognized that one of the common consumer motivations is emulation, an attitude sometimes

56

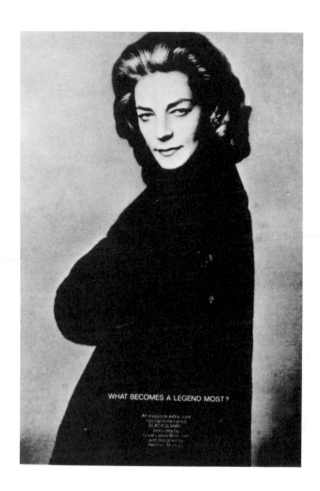

WHAT BECOMES A LEGEND MOST?

An exquisite extra-dark
natural mink called
BLACKGLAMA®
bred only by
Great Lakes Mink ...
and designed by
Norman Norell.

Endorsement: *Perhaps one of the most enduring and successful endorsement campaigns is the one for Blackglama that puts celebrities in their mink coats but does not identify them. The advertisement is from the original series based on a concept by Peter Rogers. The art director on this ad was Henry Wolf, and the photograph is by Richard Avedon.*

expressed as "keeping up with the Joneses." This form of advertising strategy ranges from the testimonials of sports figures for the body-building properties of breakfast cereals to the draping of mink on the shoulders of celebrities to promote the glamorizing quality of this luxury item.

Endorsement can be inferential through mere association of a product with a well-known subject; the association is sufficient to imply value or quality. Or endorsement can be direct, with quoted recommendations. From the beginning, there were doubts about the credibility of this form of advertising because the identification of the product may come out a poor second to the identification of the celebrity. To counteract the lack of credibility that can occur between celebrity and product, some advertisers, particularly in

Narrative: *The time-compressing character of television makes it possible to create mini-movies in the span of 60 seconds. This commercial tells the story of a teacher's last day at school before having her baby and leads to an appeal for United States Savings Bonds. The art director was John Clarke, Mary Cieary the writer, Norman Griner the director. The agency was Leo Burnett.*

television, have turned to testimonials by what they call "real people" who often turn out to be real actors who have been typecast into the role.

There have been successful examples of this strategy (see page 56), but these are exceptions to a long list of short-lived and undistinguished advertising campaigns.

Narrative

Story telling is one of the oldest strategies in the communication of ideas. In advertising the narrative can take many forms. It can sometimes disguise itself as fiction in a magazine, but if it succeeds in looking too much like editorial content, it may be penalized by having the slug "advertisement" placed above it to warn off unwary readers.

One of the most popular ways of presenting a narrative concept is through the use of sequential illustration. This can take many

UN MOMENT DE MARTELL

Association: *When the reader associates a product with an appealing ambiance, it can heighten the appeal of a product as in this ad for Martell Cognac. The art director was Lars Anderson, and the photographer was Bruce Laurance. The agency was Richard K. Manoff.*

forms. It can follow the panel and balloon format of the comic strip; it can follow the lines of photojournalism with a series of related photographs and captions; or it can sometimes be presented as a single story-telling picture.

The narrative concept in advertising is not without its own weaknesses. In spite of its unquestioned ability to attract attention and arouse interest, it has a tendency to lose credibility because of its association with fiction, and unless there is a positive relationship between story and product, there is a likelihood that readers or viewers will remember the story situation at the expense of product identification.

In recent years television has demonstrated a natural affinity for narrative concept in commercials. As creative directors and producers have become familiar with the time-compressing potential of this medium, they have created some remarkably effective mini-movies confined to a minute or less (see page 57).

Association When we associate a product or a service with a pleasurable experience, our attitudes are bound to be favorably influenced

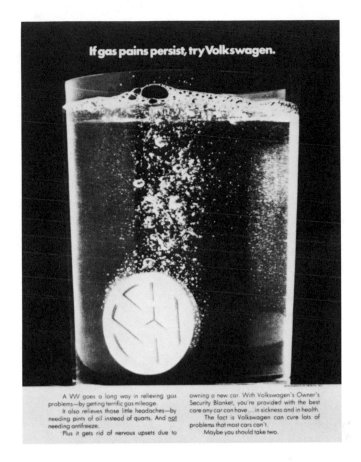

If gas pains persist, try Volkswagen.

A VW goes a long way in relieving gas problems—by getting terrific gas mileage.

It also relieves those little headaches—by needing pints of oil instead of quarts. And not needing antifreeze.

Plus it gets rid of nervous upsets due to owning a new car. With Volkswagen's Owner's Security Blanket, you're provided with the best care any car can have...in sickness and in health.

The fact is Volkswagen can cure lots of problems that most cars can't.

Maybe you should take two.

Inversion: *When a concept is twisted to serve a different purpose, the result can be both amusing and effective. In this Volkswagen advertisement, an Alka Selzer theme is bent to sell VW economy of operation. The art director was Steve Graff, the copywriter Jan Talcott, and the photographer Phil Marco.*

(see page 58). Similarly, when the atmosphere or ambiance is favorable the object that we associate with it will benefit. The early Volkswagen advertisements deliberately avoided pictorial background or atmosphere association because they wanted to give the impression of a no-nonsense product. In this instance the lack of atmosphere became a positive association, but for many products, an association with the right ambiance has an inferential value.

If association is not used with skill and imagination, the ambiance may smother the product being promoted, or if the connection is obscure or inappropriate, the result may be ludicrous.

Inversion

What I have chosen to call inversion, while not exactly a strategy, is one of the most important approaches to concept formation. It is more commonly referred to as "a twist" or "turning an idea around." It is at the root of puns, jokes, and humorous situations. It is a well-known literary device and is closely identified with the short stories of O. Henry, with their often oblique endings. In recent years inversion has played a critical role in the concepts for scores of TV commercials.

Like so many of the approaches in this chapter, inversion can be illustrated by one of the ads for Volkswagen. This advertisement takes a slogan from a very different product and turns it to its own use. The headline is "If gas pains persist, try

Emotional appeal: *This 30-second television commercial evokes the warmth and wonder of childhood to encourage long-distance telephone calls. John Walsh was the art director, Dick Keith the writer, and Fred Levinson the director. The agency was N W Ayer, and the client was American Telephone and Telegraph Company.*

Volkswagen," and the inverted meaning is clear. The copy ends with yet another amusing twist when it says "Maybe you should take two."

Turning ideas around is basic to the process of innovative thought. It closely parallels Edward de Bono's theory of "lateral thinking" described in chapter one (page 12), and it is the force that can draw us away from the straight line of logical thought when a new solution is called for.

Emotional appeals

In one way or another, all strategies of persuasive communication are involved with emotional response. Advertising objectives,

strategies, and the responsibility and taste levels of the creative team will determine when and how these appeals are used. They range from the natural sentimental attraction of children and animals, through human needs and relationships, to the more sophisticated levels of surrealistic desires.

The positive side of emotional appeal—delight, elation, love and affection, joy, and security—is the foundation of most advertising

Compassion: *Our concern for others provides the basic appeal of this advertisement aimed at encouraging readers to view a television documentary on station WFAA-TV. The art director was Pete Coutroulis, the writer was Jim Weller, the photographer was Moses Almos, and the agency was Clinton E. Frank, Inc.*

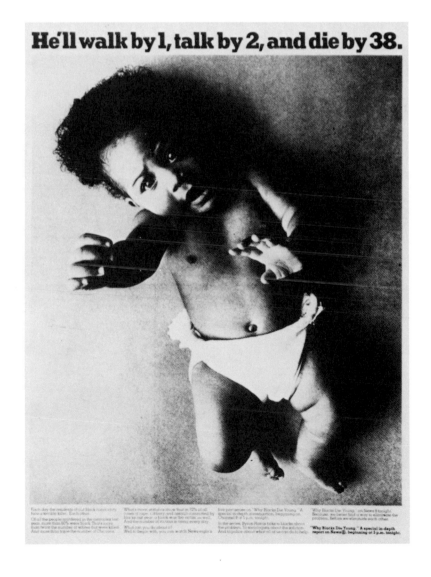

62 **Romance:** *In this skillful and amusing parody of scores of romantic television commercials, soft music and slow motion built up to the concept, "The closer he gets . . . the fatter you look." The product is lowfat milk by Foremost Food Company. The art director and producer was A. Gig Gonella, and the writer was Patrick McInroy. The advertising agency was Dancer Fitzgerald Sample, Inc.*

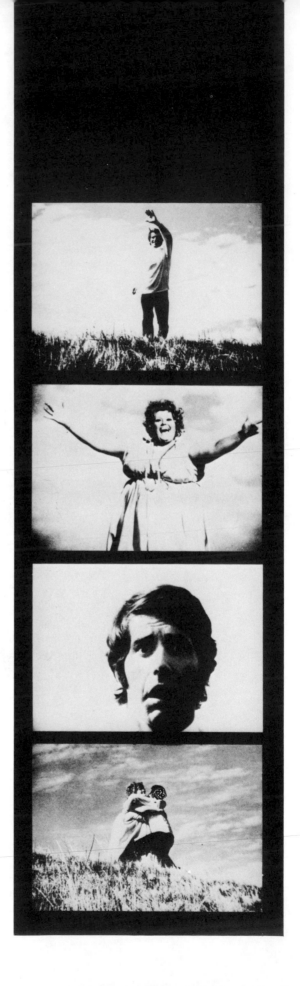

concepts. The negative side—fear, anger, jealousy, envy, shame, rage, and guilt—is usually avoided, but can sometimes be exploited with considerable success.

Motivational research was developed to identify and exploit existing emotional needs and has often subjected advertising to some of its most severe criticism. Motivational researchers defend their position on the ground that people have always used influence and been subject to influence in their own decision making. Perhaps the real issue is the morality of the persuaders' objectives—far too complex a subject for this study of the design concept. The emotional needs that advertisers most often focus on will be discussed here.

Self interest: Advertisers didn't need Sigmund Freud to remind them that ego satisfaction is central to successful selling, and it only takes a casual survey of contemporary advertising to demonstrate how strong and consistent the appeal to self interest is.

Sex appeal: As a key force in human relationships, the appeal of sex in advertising may equal the appeal of self interest. A list of all of the different ways that sex has been applied to advertising concepts would be longer than Leporello's catalogue of Don Giovanni's conquests in Mozart's opera.

This libido-based appeal has moved a long way from the Victorian cigarette cards that used the female figure to gain a man's attention and the early corset advertisements designed to help her gain that attention. There has always been a delicate line between lust and good taste. When a provocative television commercial goes too far in stressing the sensuality of tight-fitting jeans, it may set up negative reverberations among sensitive family viewers and even stir a backlash from many women who consider it to be "sexist."

Concern and compassion: Important as the ego is, we cannot overlook the fact that we are part of a society, and we should never forget that our own sense of well-being can be influenced by the degree of our compassion and our concern for others. Identification with family, friends, and community stands behind some of the best examples of persuasive communication. These are the advertisements aimed at aid to others, the cause of

Sex appeal: *The effectiveness of this campaign for The Napier Co. is based on the affinity of flesh and gold. The advertisement was designed by Gene Federico with a photograph by William Helburn.*

"Well, they said anything could happen."

SMIRNOFF VODKA

Remember whatever happens, don't overdo it.

64

Fantasy: *In recent years there has been a pronounced trend toward surreal and dreamlike images in advertising. The current campaign for Smirnoff Vodka in England is based on bizarre incidents like this flying carpet fantasy. The art director was Kit Marr, Paul Cardwell the writer, and Robert Dowling the photographer. The agency was Young & Rubicam.*

peace, conservation, better education, and better understanding of social needs (see page 61).

Dreams and surrealism: Emotional responses are often related to and guided by preconscious and even unconscious levels of the mind. This takes its simplest form in advertising as dream fulfillment. Dreams and sexual fantasy can form the background for many product promotions including fashion and cosmetics, and it is this form of advertising that promises readers the chance of awakening rich, on a tropical island, "in a Maidenform bra," or on a magic carpet .

A more sophisticated application of fantasy uses images derived from surrealist art. In recent years the paintings of Rene Magritte have become a source book for many advertising illustrations. The advertisement with the raining cigarettes (page 54) may have been inspired by Magritte's Golconda with the raining men.

Fear: For the most part this study of advertising strategies has concentrated on the positive forces that reinforce product desirability, but there is another side of the persuasive coin. This is the strategy that suggests all the dire consequences that may ensue if we fail to respond to an advertising message. The example that springs to mind is the strategy that made a product called Listerine into a household word. This product based its

Fear: *This persuasive force has had almost as much abuse as use in advertising. An exception has been a campaign for Talon that takes an amusing view of our embarassing fear of zipper failure as shown in this DKG advertisement, designed by Frank Fristachi with a drawing by Robert Grossman.*

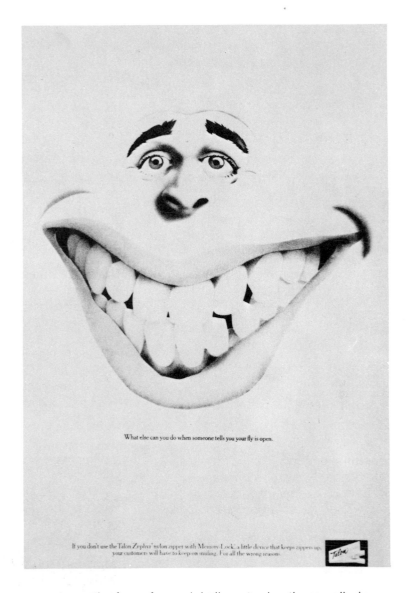

What else can you do when someone tells you your fly is open.

If you don't use the Talon Zephyr nylon zipper with Memory-Lock, a little device that keeps zippers up, your customers will have to keep on smiling. For all the wrong reasons.

success on the fear of a social ailment advertisers called halitosis—an elaborate pseudo-scientific term for bad breath. Around it Listerine built an advertising campaign based on the fear of social ostracism.

The appeal to fear has provided the background for promoting most products concerned with what modern society calls personal hygiene, and it has been responsible for a large measure of the criticism leveled against advertising. In recent years fear has become an important aspect of political advertising and propaganda.

There is one example in advertising of a humorous twist given to the fear strategy. For many years Talon, a maker of zippers, has produced a series of amusing advertisements based on the social embarrassment that might result from the failure of a competitor's product.

Point-of-sale

Most design strategies and their resulting concepts apply to all of the design media, but design for the point-of-sale introduces some new constraints and opportunities to the process. This medium includes two categories—packaging and display—both of which are three dimensional.

Three dimensional design: Most two-dimensional designs such as advertisements, posters, and printed matter depend on perspective or isometric projections to convey a three-dimensional illusion. The television screen is also two dimensional, but the time-and-motion equation heightens the illusion of dimensional space by permitting an object to be turned to reveal all of its aspects. In the design of point-of-sale material the third dimension is real, and the designer is required to adjust his perception and technique accordingly. Now his forms take on

Dimensional design: *The traditional and remarkably protective egg package of Japan reminds us that the function of packaging can take many different forms.*

Packaging: *The graphic treatment of packaging is a many-sided problem. In the Paragon package (above), designed by Alan Chan Yau Kin, with a photograph by art director Kevin Orpin, the continuous images go together to form a large display area. In the pack for Lubalin Delpire (right), designed by Annegret Beir, with an illustration by Peter Weiss, the dimensional quality is enhanced by the design.*

volume, and the square, circle and triangle of two-dimensional design become the cube, sphere, and cone or pyramid.

Package design: This is a broad subject and the technical aspects are too complicated for a study on design concepts, but the creative challenge it brings to the designer is worth consideration. The graphic designer will rarely be involved in the design of the product, though he may be responsible for its surface identification. The designer will often become involved in the form as well as the graphics of a container, whether it is glass, plastic, or board.

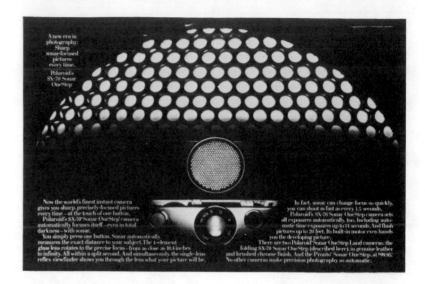

It is possible to arrive at a three-dimensional concept by visualizing the ideas on a two-dimensional surface, but most designers find that there is no better approach than with a three-dimensional mockup in actual or reduced scale. In this way he can hold it, turn it, and study the design potential from all angles. The design of a simple carton is concerned with six surfaces: the front, two sides, the back, and the two ends. Only three of these surfaces can be seen at any one time except when the material is transparent. Without a dummy carton the designer is inclined to treat each surface separately and perhaps forget one or more surfaces. Because holding a package is a tactile as well as a visual experience, a designer will often consider the feel of a surface as well as its graphic context and color.

Another dimensional influence that has a bearing on the design concept is the form that a group of the packages will take when they are displayed as a mass. How do they stack on a shelf? Is there a useful relation of different sides when they are shown together? Does the mass effect make the item stand apart from the competition? How do they look when they are displayed at random in a bin? How will the colors react to the sometimes harsh lighting of a supermarket? Many design firms that specialize in packaging simulate actual in-store conditions in their studios to measure the legibility of a design, its connotations, and its potential response.

Display: This is another area of graphic design that needs three-dimensional thinking. Whether it is designed to hold and promote a packaged product or whether it is devoted to a service like travel, the environment in which it will be used is important. Will it be flexible enough to adjust to different space options? What eye level will it be viewed from? Will it work from all angles of view?

All point-of-sale exercises are closely associated with marketing and merchandising strategies and form a direct link with communication and customer response. Because of its specialized requirements point-of-sale design is usually the

makes it an ideal background for a study of advertising strategies.

The creative teams assigned to this account have effectively used humor and inversion—the ability to twist the expected into the unexpected. By using simple graphic presentation they achieved universal identification for a product that was almost unknown when the campaign began. Through an imaginative use of television and publication advertising, the agency demonstrated the unique advantages of the product. They used narratives on television to add conviction to the demonstrations. Although the campaign ranged over a broad area of appeals, it held to a simple declarative presentation of both word and images. In the 1970s when Volkswagen dropped the original beetle for a new line of front-wheel-drive cars, they demonstrated the flexibility of the format by moving into a new level of appeals as simply as shifting gears.

No single product can be a perfect representation of all of the strategies in concept formation and Volkswagen is no exception. Strategies such as product endorsement and atmosphere association are best studied in other campaigns. The psychological appeals of this advertising have been simple and subtle, with little emphasis on direct emotional response. This does not minimize the importance of the full spectrum of strategies and appeals in the promotion of other brands and other types of products.

Advertising has developed an extensive arsenal of persuasive options. Unfortunately, too many creative teams have used these options as formulas for advertising effectiveness and have missed the fresh viewpoints that might lead to original and even more effective design solutions. There are many reasons why so much advertising is breathtakingly naive. One is certainly the layers of frequently unqualified decision-makers that an idea must filter through, but the creative participants have a measure of responsibility. Designers who lack the training, talent, and confidence to make correct value judgements cannot successfully resist the pressures that will eventually bend their efforts toward banal solutions.

Presentation concept: *Sometimes when the design is the dominant influence, it can be the concept. The recent advertisements for Polaroid's new Sonar OneStep camera (left) and the Porsche 924, with the diagram of surface protection (right), are two examples of the presentation concept. Both advertisements were designed by Helmut Krone at Doyle Dane Bernbach, Inc.*

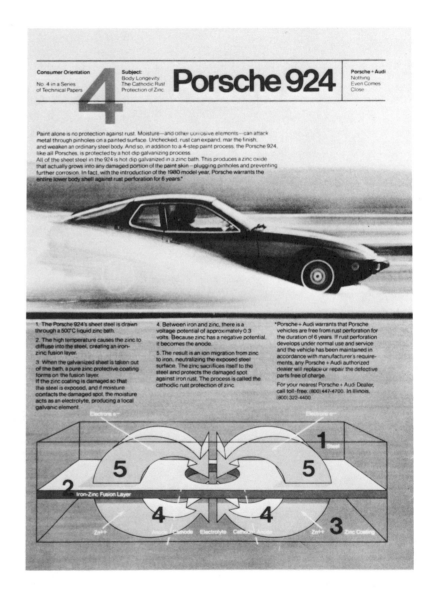

responsibility of special departments of an advertising agency or independent design firms that are sometimes concerned with product design as well as packaging.

Design as concept

Recently William Bernbach was quoted as saying, "The treatment can be the concept." Coming from the advertiser who is credited with originating the modern word and image approach this may

sound like a form of blasphemy or a paraphrase of Marshall McLuhan's contention that "The medium is the message." He was, in fact, referring to what is currently called "the presentation concept," and it applies to those advertisements where design is the dominant, but not exclusive, element. Perhaps the best way to amplify this description is through visual examples.

The advertisements designed by Helmut Krone for Polaroid and Porsche (pages 68–69) are excellent examples of the

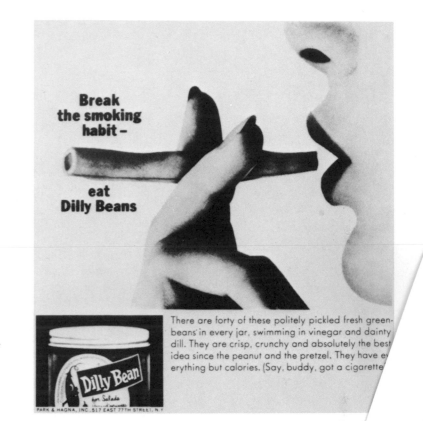

There are forty of these politely pickled fresh green-beans in every jar, swimming in vinegar and dainty dill. They are crisp, crunchy and absolutely the best idea since the peanut and the pretzel. They have everything but calories. (Say, buddy, got a cigarette

Continuity: *Another outstanding example of advertising consistency and continuity is the Doyle Dane Bernbach campaign for Chivas Regal. In this campaign the "unique selling proposition" is its high price and all that it implies. The advertisement at the right turns an old proverb to a new purpose. The design was by Charles Gennarelli and the writing by Larry Levenson.*

New Product: *A classic example of ideas offsetting a low budget in the introduction of a new product was the campaign for Dilly Beans. This entertaining advertising for an unusual product was produced by George Lois and Julian Koenig.*

presentation concept. They are innovative in design heavy emphasis on visual ideas, but as in nearly all concepts the words play an important, if supporting these two advertisements do lack, and what may is the catchy headline that has been identified with advertising concepts.

Summary

The concept approach to advertising took its decades after 1940, and by 1960 concept wa word. Much of the credit for this developmer Bernbach, a founding partner of the Doyle advertising agency. The landmark advertis the style for this word-and-image approac campaign that began at the end of the 1 established its unique position by the c of its effort as well as the variety of ther

4

Editorial concepts

4. Editorial concepts

The previous chapter emphasized the need for a smooth working relationship between copywriter and art director in creating advertising concepts. This chapter will focus on the equally vital need for creative communication between editor and art director on magazines. One of the earliest examples of this dynamic interchange was the relationship between editor Frank Crowninshield and art director M.F. Agha that helped weld *Vanity Fair* into America's first modern magazine in the 1930s. The creative exchange between editor Carmel Snow and designer Alexey Brodovitch at *Harper's Bazaar* is another early example.

It is generally conceded that during the 1960s magazines were at the peak of their success, and this interaction of editorial and design forces continued throughout this period. For example Henry Wolf has credited much of his *Esquire* success to the influence and creative encouragement he received from Arnold Gingrich, one of the truly great editors. Also, Otto Storch's design at *McCalls* developed only when Herb Mays became the magazine's editor. The team of Milton Glaser, art director, and Clay Felker, editor and founder of *New York* magazine, is already a legend. My own experience at *Look* magazine also confirms the significance of the relationship between art director and editor. It was only when Dan Mich rejoined *Look* as its editor that I was able to develop the style and character of its visual presentation.

What the designer can learn from this traditional editor-designer relationship is that art direction cannot be detached from the communication process and the personal level at which it finally takes place. No matter how large or small a magazine's circulation, no matter how many times each copy changes hands, that audience is made up of individuals, and the

Cover concepts: *The influence of persuasive advertising techniques on magazine covers is clearly revealed in this George Lois concept for a 1969 Esquire cover. It was one of more than 90 that he created for editor Harold Hayes that were destined to change the face of many modern magazines. This cover features Pop artist Andy Warhol sinking into the contents of one of his favorite subjects. Warhol willingly posed for the spoof, but the soup can was added later in one of Carl Fischer's many ingenious photographic assemblages created for this cover series.*

significant exchange takes place only when each individual reader picks up his copy and opens its pages.

Every square inch of a magazine needs some form of visual thinking, but in general there are three principal areas where design concepts play a critical role. The area of first exposure and key importance is the cover; the second is in the visual presentation of individual articles and features; and the third is the concept that determines the overall format of a magazine and contributes to the establishment of a magazine's personality.

The influence of magazine design on advertising and the effect of advertising concepts on editorial presentation have formed one of the busiest interchanges in graphic design. Because magazines have been spared some of advertising's constraints and have avoided the compromise-breeding exposure to plans, boards and client meetings, they have been able to do more

Collage: *Another example of George Lois's sometimes outrageous* Esquire *cover concepts features the head of Aristotle Onassis attached to a muscle-bound torso to create a super-machismo effect.*

visual experimenting. Most artists and photographers find that they have greater creative freedom on editorial assignments than in advertising, where a single photograph may occupy a million dollars worth of space.

If magazines have served as a proving ground for graphic ideas and new forms of expression for advertising, advertising has in turn had a different, but equally significant, influence on editorial presentation. The dominant force in advertising is persuasion and the measurable movement of goods. While editorial response is not always easy to measure, there is no question about the need for persuasion, particularly in mass-circulation publications. The magazine not only needs to be sold to an ever-increasing audience, it needs to be read by that audience if it is to survive as a viable property.

Covers

It is not surprising that one of the first and most successful applications of the concept approach to covers was initiated by an advertising art director, George Lois. In 1962 he agreed to become the design consultant for the *Esquire* covers and apply his already impressive advertising skills to this form of

Concept art: *Two of the* New York *magazine cover concepts developed by editor Clay Felker, design director Milton Glaser, and art director Walter Bernard. While* Esquire *had concentrated on photographic effects,* New York *used both photography and art work. The cover on the left (above) is by Dick Hess and the one on the right is by Paul Davis.*

persuasion. By selecting an editorial feature with a unique appeal he was able to build a word-and-image concept that would encourage maxiumum interest in the issue (see pages 75, 76). In a ten-year-period he turned out over 90 brash and provocative covers for *Esquire.*

Sometimes words dominated these concepts as in a Viet Nam cover that took this quote from a feature: "Oh my God—we hit a little girl," and placed it in stark white letters on a black background. But most of the covers relied on photographic images and many of these were visual jokes like those illustrated here with photographs by Carl Fischer. George Lois may not have been the first designer to use concepts as cover subjects, but his *Esquire* covers became a milestone on this creative direction.

Other magazines expanded and developed the concept approach. Clay Felker and Milton Glaser built the success of *New*

Cover logotypes: *The treatment of the title of a magazine on its cover is an important factor in identification, but logotypes sometimes need updating. The first cover of* Life *magazine (above) shows the original logotype, and the issue on the right shows its new, modified form. The cover design is by art director Bob Ciano and the logotype has been revised by Sheldon Cotler to conform with contemporary typographic taste.*

York magazine on an ingenious and imaginative extension of this technique (see page 77), and it has been widely used on other magazines including *Rolling Stone, Psychology Today, Time,* and *Newsweek*.

The concept approach can be highly effective when it is used with skill and imagination, but it is not the answer for all magazines. It would be as wrong for the *New Yorker* as it was right for *Esquire* in the 1960s. Magazines like *Reader's Digest* and *Cosmopolitan* use provocative contents listings while

retaining traditional visual imagery on their covers. In some cases the personality cover is still the right answer. In the final analysis, the cover is such an important indicator of a publication's personality and style that the editor and the designer must make the creative decision about its direction.

There is one other creative aspect of cover design that merits attention—the logotype. How will the name of the magazine be expressed? The problem bears a resemblance to that faced by the designer of corporate images, and there are as many solutions as there are magazines. When you consider that more than one hundred new titles appear every year, it gives you some idea of the scope of the problem. Many new magazines will vanish after a few issues, but the logotype being designed today may last for a very long time—the *New Yorker* logotype has been unchanged for over fifty years. Other logotypes change from time to time—*Life's* was updated when the new editions began publishing (see page 78); *Esquire's* was changed after fifty years, only to be changed back again; and the logotype for *Time* magazine has been modified on several occasions, but the covers still retain some of the character that designer T.M. Clelland gave to the first issue.

Features Recently there has been considerable interest in the encouragement of speed-typewriting courses for graphic designers to prepare them for keyboard-generated graphics of the future. An equally good case might be made for a speed-reading course to equip the publication designer to cope with the increasingly complex content of magazines. Editorial art direction should be—but rarely is—deeply committed to word content. When magazine art directors complain that the editors are moving in on the design function, it may well mean that the art director has made too little effort to understand the editorial needs of the publication.

Every magazine feature has its own special requirements, and for every feature, there are a great variety of design approaches; but the analytical phase of magazine design is influenced by the answers to some practical questions: How many pages have been assigned to the feature? What are its optimum space requirements? How many words of text have to be fitted in? Have the words been written, or will they be prepared to fit the layout?

Feature treatment: *The layout at the top by Carveth Kramer for* Psychology Today *uses a dramatic closeup by Carl Fischer to begin a text feature on fatherhood. The layout below by B. Martin Pedersen for* Nautical Quarterly *uses thin rules to establish typographic order in a photographic essay.*

Does the material lend itself best to visual or verbal treatment? Are there existing visual images, as in a photo essay, or will visual material be tailored to fit the concept, as in food and fashion pages? Does the nature of the content suggest special graphic translation into charts, graphs, maps, or diagrams?

These are only a few of the questions that may have to be answered before the creative phase of the project can begin. Behind these questions and their answers is the designer's need to thoroughly understand editorial intention and the potential reader response.

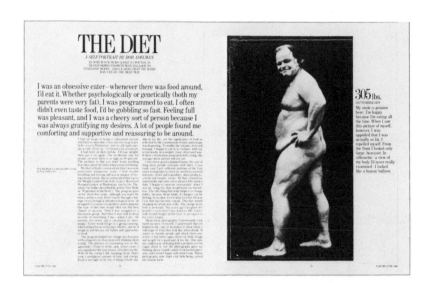

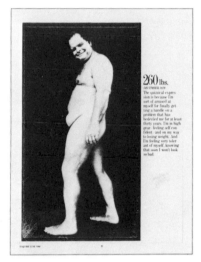

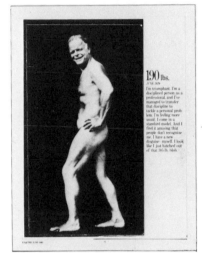

Continuity: *The overall concept for this unique and highly personal self-portrait by photographer Bob Adelman for* Esquire *has a built-in continuity. The use of typographic rules in the layout enhances the continuity. The art director was Robert Priest.*

The simplest space unit is the individual page or spread. Here the design problem is to organize the material to both attract attention and define the limits of the page or spread. A self-contained spread layout that looks like the beginning of a multiple-page unit may give the reader a sense of falling off a cliff when he turns the page to find that the feature has already ended. In designing a single-page unit, the designer should be concerned about the facing material. If it is editorial, will it have a separate-but-equal look, and if the facing content is advertising, will it clash?

In larger units of space, the objective is to give the layouts a sense of unity and continuity. In its simplest form this means a strong visual and/or typographic opening sustained for the rest of the unit by continuing text. Even in this form there is often a need to support the opening by secondary headlines on subsequent units of the feature. This creates a second chance to capture the interest of a reader who may have drifted past the opening spread. This technique has the added value of serving those readers with the perverse habit of reading magazines from the back to the front.

82

Illustration: *The spread designed by Tom Lennon (top) uses a modified photographic treatment to dramatize a concept on cosmetic surgery for* Emergency Medicine. *The art director was Ira Silberlicht and the photographer was Shig Ikeda. On the other hand, the layout below uses artwork by Don Ivan Punchatz to illustrate an article for* Playboy *magazine. The art director was Arthur Paul and the designer was Gordon Martensen.*

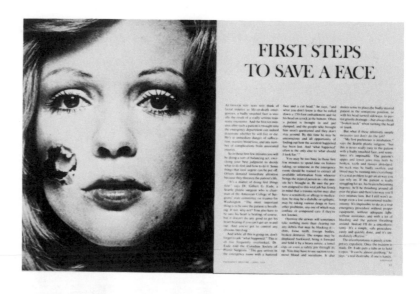

Sometimes interest is better sustained in a multiple-spread feature when the illustrations have a continuity throughout the space. It is possible to work out a visual concept with photographs or artwork that will emphasize this sense of continuity (page 81). To achieve these creative solutions it is essential that the art director work closely with the photographer or illustrator on the development of the visual pattern.

Typography: *There is no better contemporary example of the use of typography as a concept than the pages of U&lc (Upper and lower case), where Herb Lubalin has created a varied showcase of modern typographic design.*

The combination of talents—art director and illustrator—is one of the most important ingredients in successful visual presentation. The collaboration should begin as early as possible so that both parties can make maximum contribution to the concept. When the art director is overly specific in his direction, he may inhibit the creative freedom of the photographer or artist and limit his contribution. On the other hand, if the illustrator's results are to be compatible with the editorial objectives he will have to understand the problem clearly. Some photographers and artists will need more guidance than others, and the art director will have to determine the delicate and correct balance.

In designing spreads and features the art director should not overlook the opportunity to use typography as a basis for the concept. The headline—if it's a good one—is often the most provocative part of the presentation. In a highly visual magazine a straight text unit with imaginative typography may be a welcome change of pace. The measure of typographic freedom will be

somewhat controlled by typographic constraints of the format. Where all headlines are in a specified typeface and size there are still possibilities to create the occasional departure from the norm, and the contrast will be even greater than in a format based on typographic freedom.

Another way to achieve a sense of typographic variety and surprise is by the placement of the headline. It is traditional to position the headline immediately above the opening text of a feature, but there are times when it is effective to place the headline within the text area, at the bottom of the page, or in any other position that is consistent with the design and not confusing to the reader.

Format

The character of a magazine is determined by the editorial objectives and its broad approach to communication, but its style is a combination of these elements and the physical form of its presentation. The format falls into two very basic categories. One is the "continuous format" that permits each feature to run without interruption. In this format there are no lines reading "continued on page . . ." Examples of this format are *Time, Newsweek*, and the *New Yorker* as well as highly visual magazines like *Life* and *People*. The second category of magazine formats is usually referred to as the "sandwich format." In this pattern the main editorial section appears in or near the center of the book, with advertising, departments, and continued matter occupying the front and back. Magazines using this format include *Vogue, Gourmet*, and most of the women's magazines.

The sandwich format has the virtue of creating an uninterrupted editorial section, but often the seemingly endless sections of advertising in the front of the book gives the impression of a vast catalogue that dims the editorial content. The back of the book also presents problems of clutter and fragmented content.

The continuous format has the advantage of creating an uninterrupted space for each feature, but it has the disadvantage of spreading the advertising content throughout the issue resulting in occasional editorial and advertising conflicts. Such a format is often difficult to plan and make up. On the other hand, the sandwich format is sufficiently consistent to make advance planning relatively easy.

Format: *There are two principal types of magazine formats shown here in two schematic plans. The upper unit is the sandwich format with the editorial pages (represented by black dots) in the middle. The contents page has been placed on page 1, but some magazines place it on pages 2, 3, or 4. Others may place it on a page near the begining of the editorial section. Because of the pressure by advertisers for front-of-book positions, the editorial hole is often moved further back in the magazine than the diagram indicates.*

The continuous format is shown in the lower diagram. In this format all features are continuous, and the advertising is placed either between the features or, in some cases, within them. Infinite variation is possible in this format, and it will often have a large editorial section, as shown in the second and third rows, somewhat akin to the sandwich format.

Complete issue: *On occasion, a complete issue of a magazine is devoted to a single concept. In 1968 I served as an editor as well as the designer of a special issue of* Look *magazine on the creative turmoil that took place during the 1960s. The issue included a picture essay on California called "The Incredibles" by Irving Penn; "Gallery '68," a report on the art scene by Arnold Newman; "Our False Front Culture," with words and drawings by Saul Steinberg; and a portfolio of portraits of the Beatles by Richard Avedon. The issue became a rare blend of concept, content, and design. Selected pages from this issue are shown on the facing page and the two following pages.*

Because continuity of design is so important to magazines, the design of each feature will have to be measured against the design of features around it. To achieve this, most designers arrange all of the layouts in their final sequence. By seeing them sequentially, he can often rearrange or modify the layouts for greater compatability. In his appraisal the designer will be concerned with the typography as well as the visual patterns. Because some pages will inevitably face advertising, it is a good idea to check the editorial layout against the facing advertisement at the earliest possible moment. There have been some unfortunate results when this procedure was neglected.

How does a magazine's format influence design concepts? Perhaps the main influence is the constraints that overall formats impose on the design of individual features, but the format of a magazine has its own creative challenges. The designer can use his creative talent in the development of a typographic style that will give the publication character and identification. This style may stress a single display face, employ a free use of typefaces, or set a basic framework for varied treatments.

By dividing space in imaginative ways, the designer can give a sense of cohesion to varied content and add distinction to its presentation. It is here that a designer's grid may be a useful tool. The coordinates of a well-engineered grid will not only locate and unify the columns of type, but its horizontal and vertical divisions will aid in the placement of headlines and help to determine the size and position of visual elements. The grid can also provide unity to the overall format by its continuity and serve as a valuable creative tool in page design. Generally the development of such a grid should follow rather than precede the formation of a design concept for the format in order to add to rather than subtract from the creative thinking. Grids are used with greater freedom in most magazine design than they are in corporate identity or promotion, but they can still inhibit creative performance in a tight format.

The designer will also influence the style of a magazine by choice of photographers and illustrators and by attitude toward graphic concepts. The thing to remember is that the style arrived at should be the style of the magazine. The designer's personal style may be an important contribution to this result, but it should not be so dominant that it obscures editorial objectives and reader expectations.

LOOK

50 CENTS · JANUARY 9, 1968

A special issue on **Sound and fury in the arts** from sex and violence in the movies to madness in the galleries from Leonard Bernstein to **a pullout portfolio on the Beatles**

BEATLE JOHN LENNON BY AVEDON

Sound and fury in the arts

Look again—that strange object you just walked by may be a work of art. And don't turn off that sound because it suggests an ancient, ill-tuned, superheterodyne radio. You might be obliterating one of the leading new musical compositions of the sixties.

Never has so much happened so fast in the arts. From movies to music and the dance, from painting and sculpture to architecture, literature and drama—new forms, new attitudes and a new freedom from censorship are distorting or expanding our traditional values. The art of the fifties has already faded before the onslaught of the experimental sixties. Built-in obsolescence threatens to date all art movements as fast as they occur.

A new generation of artists, influenced by Marshall the-medium-is-the-message McLuhan and the motion-oriented kineticists, has rejected classic permanence to concentrate on momentary excellence as an art icon. Multimedia "happenings" leave no more trace of their existence than a burnt-out firecracker.

From mushrooming metropolitan art centers to hundreds of culture-happy communities like Kalamazoo, Mich., Americans are concert-going, book-talking and art-buying. Armed with new affluence and leisure, this audience may be spending $7 billion a year by the early 1970's on everything from recorders to Renoirs—plus outright art fakes.

If you fear the destruction of all traditional values, relax. Realist Andrew Wyeth is still our most popular painter. *The Sound of Music* is the most successful movie ever made, and a bitter-end romantic composer, Gustav Mahler, is the new hero of the concert halls. But popularity was never the name of the "in" art game.

The art scene confounds criticism, and its pace defies comparison, is all the commotion in fact "a tale told by an idiot, full of sound and fury, signifying nothing"? Or is it the beginning of an entirely new culture? In this issue, LOOK presents a sampling of the art ubiquitous of the sixties. What these signify we leave to you and to the future.

Gallery '68

High art and low art

BY PHILIP LEIDER

Stella

PHOTOGRAPHED BY ARNOLD NEWMAN

Flavin

Smith

The Beatles

BY PATRICIA COFFIN

RICHARD AVEDON'S color folio and fold-out portrait of the Beatles, photographed for Look, opens with the picture of John Lennon; continues on the next page with flower-powered Paul McCartney.

THE INCREDIBLES

This Hell's Angels motorcyclist writes no songs of protest. His actions, his very appearance, say all he wants to say to us. Thus, a life style becomes a statement about the world and, in a sense, a work of art. Irving Penn went to San Francisco last fall to photograph some of the people who both outrage and lure us by being what they are. Looking past current rages and entertainment, Penn placed these people in a neutral, ageless environment. His pictures, accompanied only by fragments of conversation, are addressed not just to the now but to the days to come.

BY PENN

 the Minstrels

Big Brother and the Holding Company

The Grateful Dead

OUR FALSE-FRONT CULTURE BY SAUL STEINBERG

A new format for an existing magazine is often best achieved with a gradual change. There are times, however, when major surgery is indicated, and a new format can focus attention on major new editorial approaches. The problem of format is never fully resolved. No matter how well a design fits current needs and considerations, it cannot presume to be completely correct for the future. Perhaps the best answer to this is a program of gradual and continuous change, with the current issue showing only slight differences from the one before it, but with a more distinct change becoming evident when the current issue is compared with one a few years back. Publishers and editors should understand that new formats do not make new magazines. Unless the changes are related to new and correct editorial approaches, a new format may only succeed in confusing its readers.

Summary

One of the first things that a magazine art director learns is that editorial design does not take place in a vacuum. No matter how skillfully executed the layouts are they cannot be disassociated from editorial content. Unless there is a close working relationship between the art director and the editor the visual personality and style of a magazine may remain elusive. The style will also often depend on the designer's ability to work closely with artists and photographers.

Another thing that a magazine art director learns is the critical importance of continuity and balance in editorial presentation. A series of spreads strung together and designed without much regard for each other will usually result in a cluttered and confused presentation. This need for magazine continuity will extend from cover to cover of each issue and from one issue to the next.

As a magazine art director I have found that there are advantages

in sometimes switching roles with the reader. By looking at pages from the reader's viewpoint it is often possible to find obvious flaws that were obscured by concentration on the design. This applies to features, covers, and the overall effect of the magazine. Why did the reader become involved in the first place? Was it the persuasion of the cover concept, the promise of something inside, or was it the influence of previous issues? Any of these reasons may be valid and will vary with different magazines. A publication like the *New Yorker* depends on a continuity of interest, but *Esquire* may rely on persuasive concepts linked to an issue's content and *Cosmopolitan* may list a dozen choices. Whatever the cover promises should be consistent with the inside reality or the reader may feel misled.

On the inside pages the art director will be concerned with continuity and a proper balance between text, photographs, and artwork. In a continuous format, each feature should run from beginning to end in one place without breaks. In a sandwich format, even though the article may be continued in the back of the book, the break and the beginning of a new feature should be clearly delineated.

The format and general style of a publication will influence the treatment of individual features. Some magazines treat headlines in a uniform type style and type size. Others allow the designer to select typography that is in keeping with the concept of visual presentation. In either case, the editor's intention and the potential reader response will be prime considerations.

Except when the format is so rigid that all pages follow a pattern, the designer will gain by seeing the layouts arranged in the continuity they will follow in the issue. These may be in full size or reduced and they will provide a chance to check juxtapositions and avoid conflicts of design or content in advance of publication.

5

Logic and design

5. Logic and design

Most of the design concepts discussed up to now have depended on the full utilization of the creative cycle including inductive thought and intuitive imagination, but there are problems that can be solved through purely deductive procedures. Although such solutions generally lack the spontaneity and surprise that more imaginative invention creates, there have been times when pure logic has achieved impressive results. On the other hand, inventors like Edison have admitted to intuitive assistance in solving practical problems and it is almost impossible to clearly define where pure logic ends and inductive forces take over.

This chapter will focus on those areas of graphic design where analytical procedures and logic play a major, if not dominant role in the process. These areas include information design, diagraphics, pictograms, identification programs, and trademarks. This chapter will also explore design systems and modular grids as organizing elements in both pragmatic and intuitive approaches to graphic design.

Information Terms like information design, visual communication, and even graphic design are so broad in their connotations that it is impossible to use them accurately to describe specific functions. The term *information design* is often used to cover all of the areas of two-dimensional design that are nonpersuasive. Many design schools use the term as a dividing line between "commercial advertising" and more "respected" forms of graphic design. This is not a completely accurate application of the term. Some design that is concerned with "worthy" causes such as health, safety, and welfare may often be persuasive as well as instructive, and a

Information: *Design for information takes many forms. These simple one-color cover designs for the United States Department of Agriculture add a clean and useful look to the traditional fund of information they contain without adding to the cost. The designer was Myrtle McNulty and the art director was Kristina Jorgensen.*

reasonable proportion of advertising is informative.

Similarly, it is difficult to draw a line between logic and intuition in the creative process. In the design of educational material, where information finds its most rational form, the logical appraisal of content and the clarity of its presentation may well dominate the process. But even here, the designer may find an original and even better solution by using intuition to support the logical search, a solution that will overcome apathy and enhance the student's understanding by arousing interest in an imaginative way.

Logic at work

When the design process follows logical procedures, it moves directly from the analytical phase of problem solving to a final synthesis and validation. For example, in a problem that calls for a purely typographic organization of some complex information, the designer may effectively combine the analysis of that

94

Utilization of Capacity in Selected Industries, 1969-1978

Computer graphics: *This diagraphic image for Laventhol & Horwath in Canada was generated by the same computer that did the research. The computer did the plotting, but the concept and presentation needed the skill of Burns, Cooper, and Hynes, the designers.*

information with a conscious recall of stored knowledge and experience to produce a design solution. Logic alone may be able to lead the designer to a creative solution, but there is nothing to prevent the intrusion of intuitive thought, and sometimes this will occur without the designer being aware of it.

The application of logic to design solutions raises the question of how much the computer can be used to solve design problems. If computer programming is compared with the working of the mind, there are several points of similarity, but there are also several significant points where that similarity ends. A computer can store large quantities of data in many forms; it can operate on the data on instructions from the operator; it can retrieve and

deliver data in mathematical, alphabetical, graphic, or other forms; and it can be instructed to select data and process it in different ways and varying sequences. However, the computer does not have the capability to initiate action without prior instruction; it cannot make value judgements; and it cannot arrive at decisions without external direction.

There are many places where the computer can aid the designer in his search for logical solutions. Its storage and retrieval capacity can contribute in the analytical phase and it can assist in the sorting and weighing of existing data to shorten the path to the designer's own value judgments. But it cannot serve as a substitute for original thought, and until the unlikely day when the computer learns to laugh, it cannot replace the designer in the pursuit of creative design solutions.

Computers will continue to serve the graphic designer by setting his type, making his corrections, augmenting other sources of information, and when area composition equipment is sufficiently refined it may even handle some routine layouts, but not without guidance or predigested grid patterns.

Diagraphics

The word *diagraphics* is a new word coined to cover one of the most rapidly expanding areas of graphic design. It describes a variety of graphic images extending from medical illustrations, industrial drawings, and orthographic projections to maps, charts, and diagrams. It embraces new forms of informational animation including weather maps, news and financial graphics, teletext and viewdata images, the cathode ray tube demonstrations of complex subjects extending from genetic growth to outer space.

If a designer takes a brief creative look at the lowly bar chart he will get a glimpse of the potential of this form of graphic presentation. The bars in the chart can be horizontal or vertical; they can be angled or distorted; they can be in color or texture; they can go down as well as up; they can be projected in perspective or isometric conformation; they can be set close or far apart; they can incorporate pictorial images either as a background or base; they can represent such objects as stacks of coins, walls, cannons, chimneys; they can form hexagons, triangles, or diamonds as well as simple bars or extended cubes;

Diagraphics: *The dimensional illusion can be useful in graphic comparisons such as this flow chart in full color from a brochure for Nobrium designed by Mervyn Kurlansky of Pentagram.*

and they can be contained in circles or curves. These are only a few of the creative options in one form of contemporary diagrams.

If the graphic medium is film or videotape, all of the above options exist with the addition of the visual opportunities that time and motion present. As we view them, the charts can expand or shrink, divide or change their form; they can be incorporated with sound; they can be superimposed on one or more backgrounds. With the aid of a computer the bars can be turned in a full circle in any direction, and they can be animated by digital instructions. The designer's only real concern is that his range of creative options doesn't destroy the clarity of the presentation.

THE LONDON UNDERGROUND

Designed by Paul E Garbutt
Copyright London Transport Executive

Logic in design: *This route map for London Transport is an updated version of the map designed by Harry C. Beck in 1931. By limiting the direction of route lines, minimizing distance considerations, and concentrating on general directions and interconnections, Beck produced a logical design solution that has been imitated in hundreds of transportation maps.*

For many years this form of design was relegated to the more prosaic side of art and design where cartographers and chart technicians were considered better able to deal with "those boring statistics." Today designers are beginning to recognize the creative opportunity that exists in diagraphics, and management is reexamining the importance of the data these images contain. Maps are being animated and treated with graphic skill to clarify their meaning. Columns of dull tabular matter are being translated into impressive contemporary designs, and some animators have turned their skill from cartoons and fairy stories to a whole range of informational challenges.

Diagraphics are a critical factor in the illustration of contemporary textbooks and encyclopedias, educational and financial publications, annual reports, and even educational comic books. In the television and film media diagraphics are beginning to extend beyond strict educational limits into general programming.

Pictograms

These visual symbols that sometimes warn us of curves on the highway or direct us to a taxi at the airport, present an interesting challenge to the ingenuity of graphic designers. Pictograms owe their heritage to Egyptian hieroglyphics, and their first large-scale modern application was in the international highway sign system of Europe. Their importance has increased with the growth of multinational companies. Today pictograms are being applied to automotive controls and computer consoles. In some cases they are being designed to grids for electronically generated sign terminals (see page 110).

The creative problem calls for simplification that will lead to clarity, iconographic legibility, and a degree of comprehension that will transcend cultural and language barriers. The images

Pictograms: *A few of the ways in which public symbol systems have attempted to identify one form of modern transport points out the need for greater standardization.*

should be easy to read at low light levels or when they are seen briefly or peripherally. They should often work without word support, with or without color, and they should retain their legibility at great distances or in small sizes. Logic is a paramount factor, but creative ingenuity can add to the effectiveness of these iconographic images.

The three symbols here have become part of a common language. The "Do Not Enter" sign is a white bar on a red circle. The disabled sign is a clearly recognized image. The red cross is a traditional medical aid symbol.

All symbols on this page are from the AIGA program for the U.S. Department of Transportation designed by Cook and Shanoski Associates in 1974.

The lower three rows of symbols include: car rental, taxi, bus, road transport, rail transport, baggage lockers, elevators, men's and women's toilets, no smoking, information.

Identification

This form of graphic design has been with us since the first trader put a mark on his door to notify his neighbors of his service. The popular title is *corporate identity*, but today that title is not broad enough to cover one of the largest fields in the graphic arts. In addition to corporations, conglomerates and multinationals there are a great number of organizations that no longer fit under the corporate umbrella. These institutions vary from rock groups and restaurants to museums, zoos, large national structures such as NASA, and worldwide organizations such as UNESCO.

Even in corporate identification there is a great variation in the design and creative requirements. A multinational like IBM is heavily committed to information and communication, and the emphasis of its program is on graphic identification and exhibition design with product and architectural design in an important but supporting role. In the case of Braun, a German manufacturer of consumer products, the principal focus is on product and packaging. For the National Aeronautics and Space Administration (NASA) the design plan had to include identification for vehicles from pickup trucks to space shuttles.

Manual: *The graphic standards manual for NASA controls the design of uniforms as well as space vehicles and printed matter. The program for the National Aeronautics and Space Administration was designed by Richard Danne, Bruce Blackburn, and Stephen Loges.*

National Aeronautics and
Space Administration

Graphics Standards Manual

Bear	Bison	Blesbok	Cape Buffalo	Caracal	Cheetah
Crocodile	Crowned Crane	Deer	Duck	Elephant	Flamingo
Giraffe	Goose	Gorilla	Hawk	Hippopotamus	Jaguar
Lion	Monkey	Oryx	Otter	Panda	Parrot
Rhinoceros	Seal	Snake	Swan	Tiger	Wildebeest

Identification: *This project for the National Zoological Park in Washington is another example of an identification program that is not corporate. The logotype above and the animal symbols at the right were designed on a module that controlled their use on badges, refreshment containers, and signs. The design was by Bill Cannon and Lance Wyman, and the art director was Robert E. Mulcahy.*

One of the earliest examples of effectively coordinated design was the program that took place between the two wars for London Transport under the direction of Frank Pick. This program included the refinement of the now famous circle and bar identifying trademark; the development of the first corporate type face, the first modernization of the sans serif letterform, and a revolutionary transportation map (see page 97).

Olivetti, a manufacturer of typewriters and office equipment, is another pioneer in coordinated design programs. Camillo Olivetti, the founder, held that "every machine should have an appearance and an elegance at the same time." His son Adriano went even further and, like the Medicis of Renaissance Florence, became a patron of the arts of his time and insisted that good design be applied to every aspect of his company. He was one of the first executives to realize that a design program could have an influence on the morale of his workers as well as on external attitudes toward his company and its products.

All truly successful corporate identification programs have benefited from a management that had the vision to launch such a program and the consistency to see that it would continue and grow as part of the corporate strategy. Frank Pick at London Transport, Adriano Olivetti at Olivetti, Walter Paepcke at Container Corporation, and Tom Watson, Jr., at IBM were typical of the managers who made the major design programs of their companies possible.

This brief review of the historic background of the corporate image makes it clear that the analytical phase of concept formation is often complex and time-consuming. Of course, this demand will vary with the nature of the organization, but for the design consultant, there is no substitute for personal involvement. The process may take a few days for a relatively small client like a restaurant or a shop, but it may take many months if the company is a multinational conglomerate.

Signage: *Identification takes many forms. Here it simply marks the street number of an important building at 9 West 57th Street. The design was by Chermayeff & Geismar.*

Corporate Image: *Today most identification programs extend well beyond trademark design to include everything from letterheads and advertising to corporate headquarter architecture, interior design, and the identification of products and facilities. Lou Dorfsman's design direction at CBS Broadcasting even included the design of a dimensional mural for a staff dining room.*

The trademark

An organization's trademark may be a logotype based on the company's name; it may be a graphic symbol based on the initial or initials of that name (NASA, ABC, IBM, RCA); or it may be an abstract construction or pictogram (CBS-TV's eye, AT&T's bell, Shell Oil Company's shell).

The use of initial letters has been a natural shortening of overly complex names like American Broadcasting Company, International Business Machines, and Radio Corporation of America, where there was no single word that would work. In many cases the initials have become so well known that the full title of the company is all but forgotten. Other companies like

Ford, Olivetti, Mobil, and Zenith were able to use a single word from the formal title as a trademark.

The use of symbols, particularly abstract ones that often lose their meaning when they are detached from their original sales presentation, have been the target of considerable criticism. Tom Wolf, a writer noted for his acid comments on our contemporary culture had this to say in a review of an exhibition of graphic design at the AIGA: "The abstract logos, which a company is supposed to put anything from memo pads to the side of a fifty-story building, make absolutely no impact—conscious or unconscious—upon its customers or the general public, except insofar, as they create a feeling of vagueness and confusion."

This may be harsh and unfair criticism when laid against the best examples like the CBS eye and the Mercedes three-pointed star, but the criticism is certainly valid when it is laid against the plethora of symbols turned out from arrows, chemical flasks, and odd shapes by a host of design studios. Another weakness of these symbols based on function is the way they can go out of date. For example, a symbol based on an automotive steering wheel may be appropriate for a manufacturer of vehicles, but

Trademark: *Often the concept for a modern trademark must consider the possibility of animation. This animation sequence was designed by Saul Bass for the trademark he had restyled for AT&T, the Bell System.*

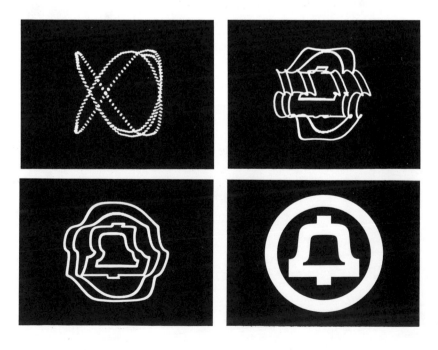

Trademark flexibility: *A well-designed trademark such as Paul Rand's for IBM is often planned so that it can be used with enough freedom to fit many different design problems.*

when the company expands into aerospace and frozen foods it may end up on the silly side.

The design of a trademark is one of the most critical steps in the development of a corporate design concept, but it is wrong to assume that the process begins here. Unless trademark concepts are preceded by a thorough study of the existing personality of a company, the aspirations of its executive level, and a careful analysis of the present and future graphic needs of

the company, there is a real danger that our brain child will suffer from infant mortality if not stillbirth.

When a proper plan has been formulated and a decision made on a logotype, initials, or symbolic representation, the design considerations come to the fore. From this point on, the challenge will rarely leave the designer's mind as he blends his experience with the recently acquired knowledge of the project; with luck and some assistance from the unconscious reservoir that feeds his intuition, the solution will come.

If initial letters are the approved direction, the designer will look at those letters in a variety of ways—examining positive and negative space, the influence of serifs, the possibility of ligatures (combined letters), and finally the appropriateness of the type style to the style of the company. This last factor—style—has an element of risk. The tendency to think of Bank Script as appropriate for a bank, a square serif letter as right for heavy industry, and delicate, curved letters as the only answer for a perfume account may represent a short cut to a banal and boring solution. How could a great design like the label for Chanel No. 5 have come about with this kind of thinking?

If the design direction is slanted toward a symbol rather than letterforms, or if it is a combination of the two, the designer will weigh the value of a clearly readable pictorial image, and a more abstract construction. Most of the early trademarks were personal symbols—the Smith Brothers and their beards reminding us of cough drops, and the famous fox terrier of RCA and HMV listening to His Master's Voice has been visible since 1900. Recently there has been a renewed interest in animals as identifying symbols or trademarks in television promotion, and some animals are earning stunning salaries as models.

It is important to remember that when they are used alone, most abstract symbols will not be associated with a specific corporation. It is only through frequent exposure that people will connect product and company. The bell symbol, recently redesigned by Saul Bass, for the telephone conglomerate may easily be associated with Bell Laboratories, but it is only through repeated use that we relate it to the parent company AT&T. Because of this often amorphous connection of symbol and corporation, it is vital that it be introduced with a prominent

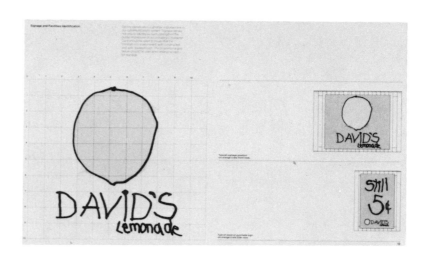

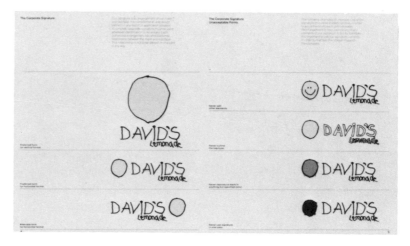

The design manual: *All corporate identity programs require a manual. This amusing parody designed by Denis Larkin and Ann Lee Polus for Sanders Printing Company contains most of the ingredients. The two spreads at the right show how the grid is used and how signage for David's Lemonade is applied to a crate. It also shows the right and wrong ways to use the trademark and the rules for color use.*

treatment of the company name and that it be positioned in the identification program with prominence, frequency of exposure, and continuous use.

The program

Coordination is the keyword of an identification campaign, and the design manual is its bible. Most programs make careful specifications of how a logotype or trademark can and cannot be used to avoid confusion or corruption. While any trademark must work in black-and-white reproduction, color is often a key to its introductory phase, and in some cases to its continued use. For example, a company like Mobil Oil Corporation with a heavy point-

of-sale emphasis, will depend on color to help achieve quick identification. On the other hand, IBM has no such color restrictions. In fact, the IBM mark is used with a rare freedom and flexibility—it can be solid black or outline, it can be multicolor, or it can be used in a striped form in either color or black and white.

The coordination of a design concept is complicated by the expanding multinational involvement of a company, the mergers and takeovers that are so commonplace, and the fragmentation of the managing structure. Most of the identity programs that are cited as outstanding—IBM, Olivetti, Mobil, and Container Corporation—have had relatively simple problems of identification. While the companies may be monolithic in scale, they have a limited number of separate divisions and a range of activity that is easy to encompass. On the other hand, corporations like Proctor and Gamble, Unilever, and General Foods are made up of a multiplicity of separate and sometimes competing brands, and their corporate identity gives way to the emphasis on brand recognition.

Even in the simplest corporate structure there is a plethora of problems. An airline will need identifying design for scores of airborne and landlocked vehicles, but its program will also embrace foodtrays, boarding passes, and matchbook covers. A banking organization will find that the quality of its interiors may be of more importance than the design of its checkbooks.

In the face of all this confusion, if the design concept is to maintain any creative standard, the designer will need courage, wide experience, and a measure of self confidence as well as imagination. It will help him to remember that it is his job to assist the client in receiving wider recognition, an increased market share, and improved internal relationships, as well as impressing the financial community. Unfortunately, too many corporate identity programs start with the intention of influencing a handful of financial analysts and the results become self serving and ineffective. This accounts for a large number of corporate identification programs that briefly come and go and clutter up the corporate landscape.

Systems The growing complexity of identification programs and corporate image making has led to an emphasis on design systems and

The design grid: *This is one of the many grids that Massimo Vignelli has used in graphic design. It was planned to handle a publication for Knoll Associates, and the coordinates were planned to accommodate both square format and rectangular (35 mm) pictures as well as four columns of type. A similar grid was used to design a wide range of Knoll printed matter.*

modular structures. Designers' grids, which divide space into units through the coordinates of their vertical and horizontal lines, are an ideal solution and valuable tool in the application of a design to a diversity of objects. Grids are sometimes used in the development of logotypes or trademarks, and they are indispensable in maintaining uniformity, as the sizes and uses of these designs vary through the program.

On occasion, a grid can provide a basic structure for an entire identification campaign. Massimo Vignelli, a leading exponent of modular systems in graphic and industrial design, recently worked out a system for Knoll Associates with a single grid forming the basis for an entire program. His grid is based on three- and four-column modules that can be divided for tabular material. The horizontal divisions of this grid join the verticals to create a series of geometric options planned to accommodate photographs in either the square format or the rectangular 35 mm

Design systems: *Grids are currently used for many purposes in contemporary design. Otl Aicher of Germany designed the grid above as a basis for the symbols used at the Munich Olympics. The body alphabet was constructed on this system of vertical, horizontal, and diagonal aspects of the square. At the right are four of the more than a hundred symbols developed by this much-imitated system.*

The newest system for Olympic symbols is indicated in the above design. Produced by Julian van der Wal of Geneva, these designs are based on an 11 × 11 unit grid and can be adapted to electronically controlled panels, (© CIO '79) Intelicence Corporation SA.

proportion. This grid has been used with considerable success for letterheads, forms, and catalogues, as well as on a large-format house organ, posters, and displays.

Another excellent example of the application of the modular approach to coordinated identification was the design system created by Otl Aicher, a German exponent of grids for the Munich Olympic Games in 1968. His system was based on two principal grids. One combined squares and angles within the square form to serve as a basis for the symbolic pictograms identifying each sporting event. The other grid used the classic square format to set the pattern for posters, schedules, calendars of events, and an elaborate signage system.

In contrast to these highly developed programs, many design schemes are only subjected to systems when the design manual is being prepared. At this stage a grid is often superimposed on an already designed trademark, and the natural unity of the design is translated into modular terms. This may sound hap-

hazard, but some successful corporate images have had similar beginnings. The important thing to remember is that while a grid can help to generate a sense of unity and continuity in a design, it is not in itself creative. In the hands of unskilled designers, grids can become straightjackets that inhibit creative concepts.

Today, many designers use grids in nearly all forms of graphic design. In addition to their place in coordinated corporate design, grids can be critical in the design of many types of informational design. Grids are useful in the design of textbooks and encyclopedias. The typographic grid is integral to most book design. In diagraphics and the development of charts, maps, and diagrams, grids are sometimes vital. The designer's grid can also serve a useful role in the formation of editorial and advertising concepts.

This chapter has closely identified the grid with logic and the pragmatic search for design solutions, but grids are not the exclusive property of deductive thought. One of the principal purposes of the designer's grid is to provide a framework for the development of creative concepts, and no modular system should exclude the possibility of intuitive thought and innovation.

Summary

Logic is an important part of the design equation. It dominates the analytical and verification phases of the process, and it may, in some instances, lead directly to the synthesis of acquired information and accumulated perceptual experience that serves as a design concept. Often this seemingly direct mutation from analysis to concept may still be influenced by intuition even though the designer may be unaware of any preconscious involvement.

All design solutions require some deductive analysis, but those involving primarily informational and/or instructional content are those concepts where logic will be dominant. The design of maps, charts, and diagrams that this study calls diagraphics are a case in point. Another design area where logic often provides a significant influence is identification. This covers a broad spectrum that may include everything from restaurants and boutiques to multinational conglomerates and international institutions.

The phenomenal rise in emphasis on information design began with the training manuals and films of the second world war and continued to grow with the information explosion that followed it. Today imaginative designers are directing their talents to this once neglected area of graphic design with some notable results.

In this same post-war period corporate identification has been increasing its share of the designer's time. Modern corporate image-making is much more demanding than the mere formation of a trademark and its application to various company properties and products. Sometimes many months of study take place before a single design has been rendered.

The trademark is an important, but not essential part of an identification program. It is possible to build a coordinated design scheme based on the style of presentation with the company name expressed in different ways, but in most cases some form of mark is essential and it will usually take one of the following forms: a company name (Ford); initial letters (IBM); an acronym made up of selected letters of the full name (Alcoa); a pictorial symbol (the CBS-TV eye); or an abstract symbol (Mercedes-Benz's three-pointed star). Whatever its form a trademark should be distinctive, legible, and memorable, and it should express the organization's personality in a way that will invite a positive response.

In an identification program, style of presentation is often as important as the trademark. Typographic unity, color coordination, and consistent design quality all add up to create that style, and it is usually summarized in the design manual.

The emphasis on organization and continuity in both informational and identification design make them natural areas for the use of modular systems. The designer's grid can guide the form of a company mark. A system built around grids can help to coordinate an image-building program. In informational design, grids can provide typographic unity in books; suggest the visual structure of illustrations; and perform an often essential role in the building of diagraphic images (maps, charts, and diagrams). The application of grids to pragmatic problem solving does not rule out its importance as a framework for the creation of new and original concepts.

Connections

6. Connections

All innovation and most design is the result of *connections*—the link between experience and action, between deductive logic and inductive insight, between the analysis of a problem and the verification of its solution. The word connections has been used as the theme of a recent International Design Conference at Aspen, Colorado, as the title of a BBC television series on inventions and innovation, and the designation of an exhibition of the work of Charles and Ray Eames.

Charles Eames, whose career as a furniture designer, exhibition designer, and filmmaker was marked by highly original concepts, believed that connections were fundamental to his own problem solving. In many ways, communication is the final and most important connection in the design process. To Eames the communication of difficult information to large audiences was essential, and the making of connections was imperative—connections between Copernicus and modern concepts, between circuses and contained environments, and between mathematical abstractions and human experience. Once, in explaining one of his designs, he said, "The details are not details, they make the product. The connections, the connections, the connections."

This chapter will concentrate on those connections that make a finished graphic design. To dramatize this view of the creative process I have asked several outstanding American graphic designers to review the beginnings, background planning, and, where possible, the circumstances under which an important design came into being.

It would have been unrealistic to expect these recollections to reveal all of the intricate connections that were involved within the

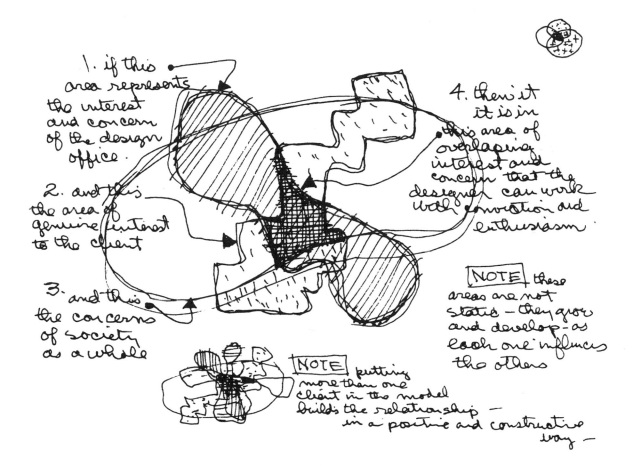

The diagram contains the following handwritten notes:

1. if this area represents the interest and concern of the design office.

2. and this the area of genuine interest to the client

3. and this the concerns of society as a whole

4. then it it is in this area of overlapping interest and concern that the designer can work with conviction and enthusiasm.

NOTE these areas are not static — they grow and develop — as each one influences the others

NOTE putting more than one client in the model builds the relationship — in a positive and constructive way —

Areas of design: *The late Charles Eames, one of the outstanding designers of the twentieth century, drew this diagram for his "Statement of the Eames Design Process" for his show at the Louvre called "What is Design" in 1969. Charles Eames con-sidered* connections *to be central to his own design process.*

designers' minds at the moment of illumination. One thing has become relatively clear to me from years of study of the creative process: wherever the creative center of the brain lies, I feel it must be far removed from the center of memory. When they do come, creative ideas come and go with remarkable rapidity. Verbal ideas move through the mind with the speed of a com-puter tape, and visual ideas are often like subliminal flashes on a dimly lit screen. Unless these concepts are recorded promptly, they may be lost forever. This makes any later recol-lection difficult, and that is why the case histories here may be lacking in some important details.

In spite of these obvious shortcomings, the recollections contain a great deal of valuable information, and they will provide the readers of this book with an interesting insight into the ways in which these projects were approached as well as a view of some of the practical problems that were encountered along the way. It is my hope that the information contained will provide designers with some useful comparisons that may help them to make their own connections in the search for original concepts.

Paul Rand: Probably no contemporary American graphic designer has had a greater influence on international design than Paul Rand. The broad range of his talent and influence has extended to include promotional graphics, corporate identity, books, publications, and advertising design. From 1941 to 1954 Paul Rand served as art director of the William Weintraub advertising agency and his fresh approach to persuasive graphics served as an inspiration to a generation of advertising art directors.

In 1954 he designed the highly honored and widely discussed advertisement reproduced on the facing page. In the following paragraphs Paul Rand tells in his own words how he solved this creative problem. The clarity of his analytical approach may overshadow the contribution of creative and intuitive forces, but one look at the end result is convincing evidence that logic alone could not have produced so much impact.

Paul Rand

Our account department had learned that the lucrative RCA advertising business might be up for grabs, and the agency decided to run an ad to make a pitch for the account. That was on Monday and the ad had been scheduled to appear on Thursday, so we were in our usual rush situation. Nothing much came out of the morning meeting of the plans board, and the afternoon brainstorming was equally unproductive. As was so often the case, I took the problem home to Weston, Connecticut, with me.

The more I analyzed the problem the more I became convinced that General Sarnoff was the key. I knew that while a million eyes might see that copy of the *Times*, the only eyes that mattered were his. I knew that his career in radio had begun as a wireless operator with Marconi, and somewhere I had heard that his proudest moment was when he was one of the first to pick up the distress call from the Titanic. This brought me to the Morse code. The letters SOS might have made an arresting headline in code, but I didn't think RCA or the agency would appreciate the connotations. It was then that I decided to try RCA in code. My dictionary provided the symbols of the International code, and I

To the executives and management of the Radio Corporation of America:

Messrs. Alexander, Anderson, Baker, Buck, Cahill, Cannon, Carter, Coe, Coffin, Dunlap, Elliott, Engstrom, Folsom, Gorin, Jolliffe, Kayes,

Marek, Mills, Odorizzi, Orth, Sacks, Brig. Gen. Sarnoff, R. Sarnoff, Saxon, Seidel, Teegarden, Tuft, Watts, Weaver, Werner, Williams

Gentlemen: An important message intended expressly for your eyes is now on its way to each one of you by special messenger.

William H. Weintraub & Company, Inc. Advertising *488 Madison Avenue, New York*

Paul Rand

knew I had the foundation of an idea.

The next morning on the 8:05 heading for the office I began putting the pieces together. In the convenient white space of someone else's ad in my morning paper, I began to sketch out the layout. From the beginning the use of Caslon typography seemed right to me. It not only had the ultimate contrast with the boldness of the dots and dashes, but it had the proper earnest tone derived from its years of association with fine books.

My first sketch was slightly top-heavy and the ad signature seemed weak. It was while I was pondering this problem that the added twist that the idea needed came to me. Almost automatically I noted that the dot and dash of the last letter in my headline became a perfect exclamation mark when it was turned on end. It was only later that I realized that the A in advertising related to the symbol. Later when the layout was submitted in finish form to the agency, the usual flack developed, and it was only when our television director joined in its defense that the idea was approved.

Did the advertisement work? If attracting a lot of attention means anything it was a big success. On the morning the ad appeared, when I arrived at the Saugatuck station, the first thing I noticed was a group gathered around a man with his copy of the *Times* open to my ad, and on the trip into New York I overheard a lot of comment. But what happened on the executive floor of the RCA Building? General Sarnoff must have seen it, because there was a call from his office later that morning to set up a meeting with our agency people. In the end the agency didn't get the RCA business for reasons unrelated to the ad and its objectives.

Saul Bass has contributed to all phases of graphic design. He has received awards for his advertising design, is one of the leaders in corporate image-making, and his work in films is known to almost everyone. He won an Oscar for his short film *Why Man Creates*; he has made a full-length feature, *Phase IV* and also the epilogues for *Around the World in 80 Days* and *West Side Story* and the prologues for *The Man with the Golden Arm*, *Walk on the Wild Side*, and *Such Good Friends*.

Saul Bass's association with corporate design has been equally successful. Saul Bass Associates, headquartered in Los Angeles, has developed corporate images for Alcoa, United Airlines, Warner Communications, American Telephone & Telegraph, and other multinational corporations. In his account Saul Bass tells how he handled one of his smaller accounts with time and budget constraints and turned it into a gold medal winner in the 1979 Art Directors Club exhibitions.

Saul Bass

My friend Stan Hart was going to have his first play—a comedy —produced on Broadway. And the director was to be Hal Prince. He asked me to do a poster for the show and I agreed because he is my friend, I admire Hal Prince's work, and I thought they would encourage something good to happen. But as is frequently the case, there was a miniscule budget available, and they had waited until the last minute.

I began doodling while flying from New York to Los Angeles. To get the essence of the piece, I verbally restated the essential condition described in the play. I tried a number of versions. Here was the one I thought was most accurate: A man who creates his own perfect (fantasy) environment in an apartment in a big city, when the rest of the world (outside) is malevolent and uncaring."

Meanwhile, dinner had been served and the dishes were being removed. A stewardess was pulling down the movie screen (I had seen the movie); I reread the simplified synposis I had just written . . . I pulled out my pad . . . and began to scribble.

The context was easy—I laid out a geometry of building piled on building, neat patterns of anonymous windows, and I had the uncaring, even oppressive big city. It seemed really only a question of how to express the fantasy of a perfect environment, I tried a few quick possibilities, a transparent cubicle, a drawer—it really wrote itself out. My key idea, using color for the inside of the drawer and stark black-and-white pattern on buildings came to me so naturally and intuitively that I took it for granted. It needed only a more careful drawing and it was done.

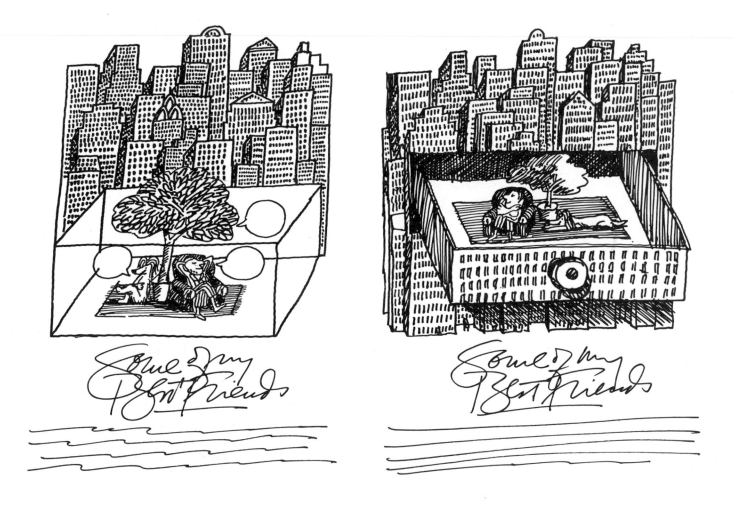

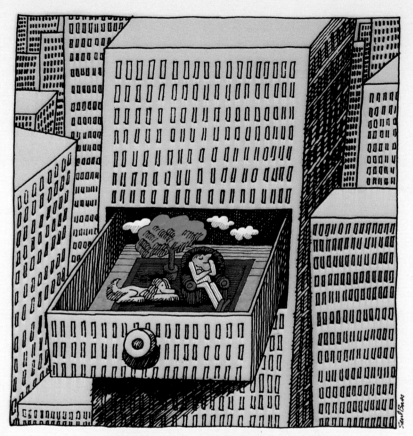

Some of my Best Friends

Arthur Whitelaw, Jack Schlissel and Leonard Soloway present 'Some of My Best Friends'
A new comedy by Stanley Hart · with Ted Knight · Lee Wallace · Gavin Reed · Alice Drummond
Ralph Williams · Trish Hawkins · Bob Balaban · Associate Producers: Donald Tick and
Martin Markinson · Production Designed by Eugene Lee · Lighting Designed by Ken Billington
Directed by Harold Prince 🌳 Longacre Theatre, West 48th Street, New York

Bradbury Thompson's design has had a significant influence on contemporary typographic style. His 59 issues of *Westvaco Inspirations for Printers*, designed between 1939 and 1962, probably included more innovative graphic ideas than any other similar series. Because the publication was a showcase of the printing art, it presented a unique opportunity for a designer to demonstrate his ability to balance restrictive constraints and creative freedom. Brad Thompson explored many sources to sustain the variety that the *Westvaco* publications required. In the following paragraphs he reminds us of how important and persistent the play instinct is in the search for original ideas.

Brad Thompson

While we had a substantial budget for four-color printing on *Westvaco Inspirations* and we were able to use some fine paper, there was only a small budget for new process color work. The tradition of the publication had been simply to reprint the more interesting illustrations from current publications and advertisements together with columns of text. But I was filled with a desire to use the facilities to a more creative and enjoyable end.

I borrowed four-color plates from museums, agencies, and publishers, but reprinted them in off-register but meaningful designs, or combined them with inexpensive line plates to express a fresh point of view. I found that eighteenth and nineteenth-century engravings from my own library could be incorporated to express vital, happy new ideas. I also found that every familiar thing around me could be translated into new graphic techniques—New York City itself, memories of my past in the Midwest, and especially my family.

At the time I was working on the Westvaco series, my four children were growing up, and I tried to find as much time as I could to play with them. I was pleased at how much this play experience helped my creative thinking. It was a perfect form of relaxation from the strain of problem analysis, and I found that after play I was able to return to my drawing board stimulated by the fresh viewpoints it gave me.

Perhaps the most interesting part of this play experience was the number of times that my children became my collaborators. One time in 1947, when my son Mark was four or five years old, we worked out an idea together without being aware of it at the time. Mark had developed a healthy interest in railroads, and that Sunday we decided to build a make-believe railroad in our living room. All we had to work with was the floor, a layout pad, and some black pencils. We arranged sheets from the layout pad on the floor, I taped two pencils together for the parallel lines of the track, and we planned our railroad line. We arranged and rearranged the route, placing the bridges and plotting the turns until we had a plan that we liked.

The next morning at my drawing board the pattern of tracks was in my mind as I began to create a layout for a *Westvaco* spread. The final layout was similar to the one that Mark and I had worked out on the living room floor, but the track itself became the text in lines of type. I selected some steel engravings from the *Iconographic Encyclopedia*, and when I added the headline, "Good design travels far and wide," the design was complete.

At one time or another all of our children assisted me in my design. Quite a few *Westvaco* spreads were translations of a young daughter's or young son's drawing. This play experience did as much for my design ideas as it did for their growing up.

George Lois has few equals when it comes to bold, original, and sometimes outrageous advertising concepts. He worked as an art director at Doyle Dane Bernbach, but in 1960, he and copywriter Julian Koenig left to establish their own agency: Papert Koenig Lois. While there, George Lois also worked as a design consultant for *Esquire* magazine, where he applied his persuasive concepts to over 90 covers.

Shortly after the agency was formed, they took up the challenge of preparing advertising for Wolfschmidt Vodka, and George Lois and Julian Koenig created an amusing and highly provocative campaign. Up to then, most liquor advertising was still suffering from a tough alcoholic beverage code suggesting that social drinking was anything but fun. George Lois managed to break through these inhibitions and he tells the story behind the inspired result below. From his analysis of product needs and communication objectives to the visual and verbal influences he traces the metamorphosis of this provocative advertising idea.

George Lois

It's hard to remember how or when you get an idea. As far as I'm concerned, it's just feeding all the input possible into my head, understanding the product, the competition, the market, the world around you, carving out a distinct position or claim for the product, and then *discovering* the selling idea. I've never thought of myself as *getting* an idea. I always discover it. After you've been through the correct discipline of finding out what kind of information you need, the idea forms itself, floats by; and if you're sharp enough, strong enough, courageous enough, you grab it and put it down on paper. My rules are that the idea must surprise *me*, be seemingly outrageous, and scare the hell out of the client (otherwise it's an expected answer).

The great Vodka drinks are the Bloody Mary (tomato juice) and the Screwdriver (orange juice). The visual imagery of a masculine bottle with a permanent erection talking to a tomato (pun intended) and an orange (with its prominent navel) beckoned.

But I always think copy lines first. The visual imagery of the

"You're some tomato.
We could make beautiful Bloody Marys together.
I'm different from those other fellows."

"I like you, Wolfschmidt.
You've got taste."

Wolfschmidt Vodka has the touch of taste that marks genuine old world vodka. Wolfschmidt in a Bloody Mary is a tomato in triumph. Wolfschmidt brings out the best in every drink. General Wine and Spirits Company, N.Y. 22. Made from Grain, 80 or 100 Proof. Prod. of U.S.A.

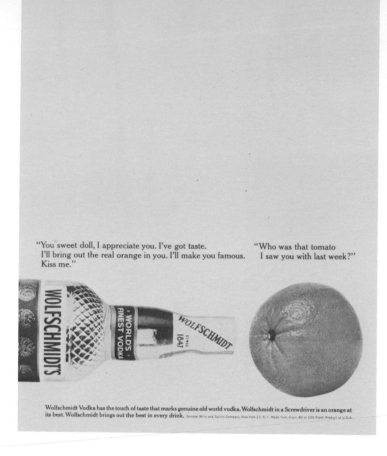

Casanova bottle seducing tomatoes, oranges, and other products associated with vodka drinking was probably the closest to a protovisual idea I've ever had (although I wouldn't swear that I didn't think of "Wolfschmidt, you've got taste" first and married the visual to it). The scale of the ad was lifesize. The type was simple, direct, broken into thoughts, the way I set all my type.

No alcoholic beverages had ever been advertised in such a simple, symbolic, erotic style. The campaign said Wolfschmidt Vodka had taste, *you* had taste if you bought Wolfschmidt, and it was a daring Vodka for mixed drinks. Week after week, new inanimate objects talked a blue streak with Wolfschmidt: lemons, limes, olives, onions, seltzer bottles (all in sexy double entendre). The virility of Wolfschmidt Vodka was quickly accepted.

Just one week after the Wolfschmidt bottle romanced the tomato it got down to serious banter with an orange. This ad did something else that was unusual: it referred back to an ad that ran the week before ("Who was that tomato I saw you with last week?"), proving that one and one make three. Sam Bronfman, that sweet tyrant (and client) looked at this ad cross-eyed, not quite sure what to make of it. "We're saying Wolfschmidt has taste," I argued. "We're saying oranges taste better when mixed with Wolfschmidt. We're saying people drink to have fun." Mister Sam didn't laugh . . . but he okayed the campaign, including the olives, onions, lemons, limes, seltzer bottles, and all my pornographic metaphors.

Milton Glaser: It is not uncommon to refer to an artist or designer as "having many hats," but in the case of Milton Glaser, it has been said that he is the possesser of many hands. When a change of style is indicated, he only has to put on a new set of hands to come up with the right solution. This versatility has brought him international acclaim as a designer and illustrator.

He was a founder of the Push Pin Studios in New York in 1954, a design organization noted for its graphic innovation. He was associated with Push Pin for twenty years, and during this period he worked with editor Clay Felker to establish the highly successful *New York* magazine. With all of his claims-to-fame, probably the line of work that he is best identified with is his posters. There is such a freshness in their design that they all look as though they came to his mind simply and spontaneously, but as his following account reveals, it's not always that easy.

Milton Glaser

The way in which I arrive at an idea varies from case to case, as I suppose it does in everyone's experience. The process does tend to fit into certain general configurations. Frequently, it's an immediate flash of response as soon as the problem is acknowledged—a kind of nonthinking reactive spasm. Then it becomes a question of working out the details. At other times, as in the case of the Professor Longhair poster, it's a fumbling, backtracking procedure.

I had known and admired the work of Professor Longhair for many years. He was recorded by the writer Albert Goldman during a remarkable performance just before his death, and I was asked to do an album cover and poster celebrating the event.

A portrait seemed desirable because Longhair was still a relatively obscure figure in spite of his enormous influence on the history of Rock and Roll. I suppose the idea of doing a likeness was the critical decision in my search for a solution. I had a few photographs to work from. The most useful showed him seated at a piano (figure 1) and another was a closeup of his face (figure 2). Using these two as reference material, I tried to do a more or less

128

1　　　　　　　　2　　　　　　　　　　　　　3　　　　　　4

straightforward portrait. I stayed in this vein for a while, but it was going nowhere.

At one point, I asked the record producer what Longhair was wearing during the recording session. He told me that he was characteristically dressed in a blue denim jean suit covered with colored patches. For some reason the phrase "colored patches" stuck in my mind (an insistent note that occurs frequently when I am working toward something.) It is like an illusive scent or a memory fragment, and if it persists long enough I have to pay attention to it. In this case I couldn't shake it off, so I did a drawing that reconciled the idea of these floating patches with a likeness of Professor Longhair (figure 3).

I let the drawing sit for a day (after some initial enthusiasm) and finally found that it didn't hold up. I felt that I had to make some reference to the piano, and the likeness had to be more believable. With that as an operative constraint, I began searching through books and photographs for a believable posture, a posture that Professor Longhair might take. I found what I needed in a book called Harlem on My Mind. The portrait was of a shoeshine man, but there was something about it that had the stance I needed (figure 4). After that it became a problem of rendering with some technical details that had to be worked out during the execution of the finished artwork.

I must say that the decisions called for in physical production of the work had many of the same characteristics as those in the conceptualization—certain decisions were made immediately, certain parts of the design were more resistent and had to be worked back and forth. At any rate, the result of all this was planned so that it could fit the square of an album cover or be trimmed down to fit a poster.

Herb Lubalin's outstanding typographic style, his remarkable ability to manipulate letterforms, and his sensitive handling of the positive and negative spaces in typographic design have led to the creation of many outstanding layouts, logotypes, and letterforms. When he was called on to design the logotype for a new magazine called *Avant Garde*, he came up with a unique solution that combined letters and created ligatures. The final design was so successful that he used it as the basis of a new typeface with the same name. This has become one of the most popular new typefaces of all time. The actual working out of the design was not as simple as it looks, and Herb Lubalin tells the story in his own words.

Herb Lubalin

The dedication page of the first issue of *Avant Garde* magazine reads: "As most of the world's ills are traceable to old imperatives, old superstitions, and old fools, this magazine is exuberantly dedicated to the future."

For one who finds the present almost impossible to contemplate, the future is absolutely beyond my realm of understanding. So when Ralph Ginsburg asked me, early in 1967, to project myself into the future and design an avant garde logotype for *Avant Garde* magazine, I felt entirely inadequate to the task.

I had three alternatives: (1) reject the job, which would automatically admit defeat; (2) reveal myself as a failure, which wittingly I would never do; and (3) make a satire of the name (which I felt was the only avant garde way to interpret what avant garde means—and what avant garde means is meaningless, since once it is seen, it is no longer avant garde.) I chose alternative number 3.

I submitted the logotype in Old English, Bank Script, Cartoon Bold, Dom Casual, Flash Italic, Wedding Text, Monastic, Buffalo Bill, and a last-ditch effort reflective of Coca-Cola.

Ginsburg said, "Stop kidding around."

I then tried to dazzle him with a multitude of ornate swashes, which usually does the trick. He said, "Cut it out!"

It was clear that I had to produce a piece of typography unlike anything done before. The juxtaposition of the letters AVA with their related slants were evident in several of my sixty abortive attempts, and it became critical in the cockeyed lettering of my final sketch. As soon as I worked out a pencil rough, I knew I had hit on the ultimate solution. I can't really remember doing it. I only remember it being there on my layout pad.

When I looked at the lettering there was a feeling that I only remember having once before in my graphic lifetime, and that was when I designed the "Mother and Child" logotype (see page 17). I knew the *Avant Garde* design would stand the test of time and remain avant garde for a long time. It was a subconscious or intuitive feeling that you get only occasionally—a feeling that you have created something that cannot be made better—by anyone.

Lou Dorfsman: In many ways Lou Dorfsman exemplifies those qualities that shaped American graphic design into a worldwide influence in the postwar years. His style is open and direct, and he is not afraid to apply his imagination to the realistic needs of business. In his nearly thirty-five years at Columbia Broadcasting System, he has produced a prodigious volume of work that has ranged from persuasive advertising for radio and television programs to corporate design and commemorative books of a limited-edition quality.

His earliest explorations of graphic design in film animation occurred more than twenty years ago; since then, he has created, directed, and supervised the production of hundreds of identification, information, and promotion films. He pioneered the development of short, specially produced films to replace the customary film clips in program promotion. Television and filmmaking demand a unique fusion of many talents, and it is often difficult to see where a concept originated or how it came into being. In the following account, Lou Dorfsman traces the background of one such film and shows how he often serves as director, producer, and father confessor as well as designer.

Lou Dorfsman

The role of an art director may sometimes seem ethereal to outsiders. It is often difficult for those not directly concerned with visual communication to accept the artistic contribution of one who does not do the finished artwork. The promotional art director, like a stage or film director, must lend focus to the work of others to insure that the final result is a cohesive and coherent entity. It is the art director who digests the information and sets the direction of an idea. Often he supplies the germ of the original concept. He is the one who pulls together the available talent and resources to complete the task, and he is the one who faces the moment-of-truth at the final screening.

When I decided to add Len Glasser to my staff as a filmmaker and designer, it was one of those decisions without precedent. Filmmaking and animation were not then considered to be a part of the internal staff function. The decision came at a time when

Len Glasser, an old friend, was going through a very difficult time, and I was in need of his kind of talent. It took a while for both of us to come up with the right combination, but finally I invented a project to fit his talent and we began a highly successful series of animated television commercials.

Having set the pattern for this animated series, it was up to me to identify specific areas that would benefit most from such a treatment. Sports coverage was a natural because of its unequalled opportunity for exaggeration, satire, and humor. The sports world's clichés, stereotypes, and malaprops are the "lingua franca" of the mass audience and provide perfect vehicles for comedy and even poignancy.

These short films were vignettes without words. The sound tracks were limited to a few grunts, groans, and thuds allowing leeway for regional stations to add their own voiceover comment.

Bringing people off the screen and into the living room is an idea that grows naturally out of the intimacy and immediacy of the television medium, and it became the key to this award-winning promotional spot. By adding the surprise payoff, as the deluge of football tacklers descend on the hapless hero of our spot, we made this simple cartoon into a "show-stopper."

Behind this successful conclusion was my gamble to rescue Len Glasser from his difficulties. Without his talent and the circumstances I created to put this talent to work for CBS, the project might never have been conceived—let alone executed with so much style and wit. It only goes to show that invention is, after all, the mother of necessity.

Most graphic designers can remember a time when an idea stubbornly refused to surface, and this series of design case histories would be incomplete without an example. The oversize wastebaskets of art directors are a standing tribute to this kind of frustration.

Henry Wolf is a designer who is noted for the variety, originality, and quality of his graphic concepts, and it is hard to think of him as at a loss for an idea. His work at *Esquire* magazine in the 1950s established his reputation as a designer of the first rank, and many of his covers and page layouts are still regarded as landmarks of editorial design. In 1959 Henry succeeded Alexey Brodovitch as art director of *Harper's Bazaar*, and in 1961 he became art director of *Show*, a handsomely designed magazine on the performing arts.

A few years later Henry Wolf became a partner and art director of Trahey Wolf, one of New York's most creative young advertising agencies, where he developed concepts for advertisers like Elizabeth Arden, Olivetti, and Danskin. Throughout a busy career as a designer he managed to find time to take some superb photographs for covers, editorial features, and ads. When he left Trahey Wolf in the 1970s to set up his own firm, he concentrated on photography but continued to serve several clients as a design consultant. Here, in his own words, he talks about the search that nearly failed.

Henry Wolf:

In my own search for ideas, I have leaned heavily on connections with my childhood, and this may explain my continuing fascination with the curve of car fenders and the intimacy of views through windows. These are the double images of mind and viewfinder—inductive thoughts combined with perception—that lead to fresh ideas that sometimes contain surrealistic overtones.

When I took on the poster assignment for the "Paperback Show" of the American Institute of Graphic Arts, it seemed like a simple

PAPERBACKS U. S. A.: An Exhibition of Covers: 1957-1959

enough problem. It wasn't that I didn't give it enough time. The project was never far from my thoughts. But in spite of several attempts, nothing I came up with seemed to work, and as the deadline approached, I became more and more frustrated. Gradually I had to turn my concentration to other projects.

One morning I was going through some photographs that I had taken for *Esquire* of the Spanish Riding School in Vienna. They included a lot of atmosphere shots, and they were scattered all over my desk when the phone rang. It was the executive secretary of the AIGA asking me about the poster and reminding me that the deadline was last Tuesday. The phone call created a sense of panic. There wasn't any answer. I simply didn't have an idea in my head, and I could only apologize for my inability to come up with the poster.

Even as I explained my frustration, I looked down at one of the photographs on my desk. It was a picture of a man's back, and in the dim recesses of my mind it suddenly shifted to become the vision of a completed poster. So I said "Disregard what I just told you. I have an idea and the artwork will be in your office this afternoon." All it took was a few experimental tears in the photograph to create the space for the title, a quick call to the typesetter, and a color swatch and it was done.

Conclusion

By now it should be clear that the precise measurement of an idea or the wholly accurate recollection of the process of finding it are unattainable. This has been borne out by the comments and observations of the designers who have valiantly contributed their time and effort to the chapter on *Connections*. But if designers cannot find any easy answers, they can learn a great deal from the study of these experiences.

The designers' comments highlighted the connections that exist between the reservoir of retained information and the solution of current problems. This was brought out in Paul Rand's search for his idea. George Lois demonstrated how words and images can

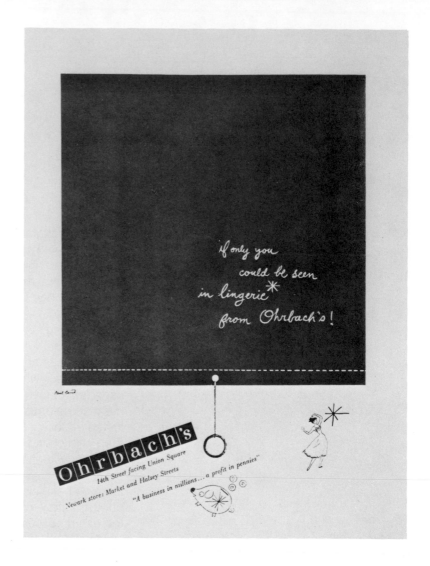

Coincidence: *These three concepts, all based on the privacy of a drawn shade were developed independently by three different designers and each serves its purpose with great effectiveness. The one at the left was designed by Paul Rand in 1946. The one on its right was designed by Saul Bass in 1958. The one on the far right was designed in 1980 by Mark Paynter in London for Crawford Advertising, Ltd.*

sometimes be twisted to create brash but brilliant ideas. Lou Dorfsman's words on the background and creation of a television spot underscores the new role of the art director in orchestrating the performance of several creative contributors to produce thirty seconds of harmonious and effective television film.

Brad Thompson's report heightens our awareness of the close relationship that exists between the play principle and creative thought. Saul Bass reminds us that the creative need is always with us—even on a transcontinental flight when the concept was revealed in one of those instantaneous flashes of insight.

On the other hand, Herb Lubalin's account demonstrates that all ideas do not surface so easily. His search for a truly avant garde style for the logotype for *Avant Garde* magazine is convincing evidence of the determination a designer sometimes needs to plow through scores of abortive ideas until he encounters the sense of excitement that signals a brilliant solution. Milton Glaser's narrative reinforces the need for value judgements along the way as first ideas are rejected in the trial-and-error search for a satisfying creative concept.

Finally, Henry Wolf's story shows us how even a highly skilled and innovative designer can sometimes be frustrated. His account of the pursuit of an idea down to the last minute of a deadline will remind other designers of many similar experiences.

Coincidence The distances between connections, chance, and coincidence are minimal. It is possible for two designers to respond to a stimulus in the same way and arrive at similar, if not identical, solutions. This is not to be confused with the deliberate bending of someone elses concept to fit a designer's purpose. A classic example of the long reach of coincidence can be found in the sometimes amusing, sometimes painful distortions that Leonardo's *Mona Lisa* has been subject to. Almost everyone has had an idea related to this painting. Fortunately most of them remain unrecorded. The cliché-ridden path extends from Marcel Duchamp to Push Pin Studios. A similar fate has befallen Hokusai's famous wave print, and Grant Wood's *American Gothic* has been parodied beyond recognition.

Sometimes it is possible for different designers to apply the same basic symbol to different problems and come up with valid if related results. The examples I have selected to illustrate this type of coincidence (see pages 138–139) are all based on the relation of the window shade to privacy. The first is Paul Rand's famous advertisement for Ohrbach's. The Second is the Saul Bass poster for *Love in the Afternoon*, and the third is a 1980 poster for Kayser hosiery. These concepts span a period of more than thirty years, and each one is effective in its own right.

Decisions

In many ways creativity is a decision-making process. While the idea itself may develop intuitively, the value judgements surrounding the immediate inspiration will have an important bearing on its completion and success. In the analytical phase most designers will follow a pattern of decision-making responses, and in the final validation phase value judgements will be of equal, if not greater, importance.

Probably the most important decisions a designer can make are those involved in the selection of one of the preliminary ideas or sketches that is most worthy of development into his final concept. It is a mark of a designer's skill when he can make the judgement to reject or follow a line of thought quickly and surely. This is one of the skills that can be developed through experience and practice.

This book has pursued, and distilled where possible, the spreading volume of research data and theory on the creative process. It has also endeavored to reveal, in as useful a form as possible, the graphic design framework in which the process takes place. In the study and in the chronicles of the designers themselves there has been support for the importance of the intuitive response that can sometimes produce an original concept in a flash. There is also support for the trial-and-error approach with its heavy reliance on logical analysis. There is strong evidence that each problem dictates its own technique, and each designer will work out his own methodology in arriving at a solution. Above all, it is clear that much of the mystery remains. Picasso's dream of a camera that would reveal "by what path a mind finds its way towards the crystalization of an idea" remains unfulfilled.

Notes & acknowledgments

So much of the content of this book is based on my own personal experience and observations that it is difficult to apply traditional forms of notation. However, because there is sufficient supporting research that may be of value to those who wish to pursue the subject in greater depth, I have appended the following notes. These reveal as accurately as possible sources of information on the creative process and the design concept.

Chapter 1

Page 10, The levels of consciousness. These are discussed by Sigmund Freud in *The Complete Introductory Lectures on Psychoanalysis*, translated by James Strachey, Oxford, Alden & Mowbry, Ltd. On pages 534–535, Freud identifies the three levels of consciousness with these words: "We call [that part of] the unconscious which is only latent, and thus easily becomes conscious, the 'preconscious' and retain the term 'unconscious' for the other. We now have three terms, 'conscious,' 'preconscious,' and 'unconscious.' "

Page 11, The four stages of creative thought. These steps were originally advanced by Graham Wallas in *The Act of Thought*, London, Jonathan Cape, 1926. His original identification referred to (1) preparation, (2) incubation, (3) illumination, and (4) verification. Wallas's four steps are also referred to by several other writers on the creative process. Two good works are *The Art of Problem Solving* by K. F. Jackson and *Experimental Psychology* by Robert S. Woodward and Harold Schlosberg, Chapter 26: "Problem Solving".

Page 11, Diagram. This representation of the creative process is based on Freud's levels of consciousness and Wallas's four steps in creative problem solving. For some of the structure I am indebted to Graham Collier, who developed a chart called "Diagram of the Compass Points of Consciousness." This is shown in Figure 3-1 in his book *Art and the Creative Process*, Englewood Cliffs, N.J., Prentice-Hall, 1972.

Page 12, Einstein and Edison. This subject is dealt with by William J. J. Gordon in *Synectics, The Development of the Creative Process*, pages 135–136.

144

Page 13, Lateral thinking. Edward de Bono discusses this in Lateral Thinking, London, Penguin Books; New York, Harper & Row.

Page 15, The play instinct. Good books on this subject are: The Act of Creation, by Arthur Koestler, Chapter 9, "Playing and Pretending"; The Dynamics of Creation, by Anthony Storr, Chapter 9, "Creativity and Play"; Synectics, by William J. J. Gordon, Chapter 5, "Play and Irrelevance"; Paul Rand, "Design and the Play Instinct," an essay from Education of Vision, edited by Gyorgy Kepes.

Page 15, Tangrams. Two books provided basic source material for this section. These are: Tangram by Joost Elffers and Tangrams by Peter var Note. I am also indebted to Paul Rand for his essay on "Design and the Play Instinct" from Education of Vision, edited by Gyorgy Kepes and published by George Braziller.

Page 16, Froebel Blocks. See Grant Carpenter Manson, Frank Lloyd Wright to 1910—The First Golden Age, New York, Reinhold Publishing Company, 1958, pages 5–10.

Page 18, Humor. See Jokes and Their Relation to the Unconscious, by Sigmund Freud, translated and edited by James Strachey, London, Routledge & Kegan Paul, 1960.

Chapter 2

Page 22, Functions of graphic design. The triangular division of functions is, in part, based on a pattern developed by Bruce Brown of the Royal College of Art in London and reproduced in an essay in the Information Design Journal, Volume 1/2, 1979, pages 123–134. The original triangle used persuasion, explanation, and identification for its sides.

Page 25, The design process. The Hans Hillmann poster and the related information are derived from Exempla Graphica, edited by Manuel Gasser, published by the Alliance Graphique Internationale with Hug & Sohne, Zurich, Switzerland.

Page 29, Precision in Design. The George Giusti material is derived from the same source as above.

Page 31, Picasso. The quotation was first reported by Christian Zervos in Cahiers d'Art in 1935. The translation is by Brewster Ghiselin in The Creative Process, New York, New American Library.

Page 31, "Le Mystere Picasso." This film was directed and produced by Georges-Henri Clouzot in 1955 and shown by the Museum of Modern Art in the following year. The account is based on personal recollection and reference to a pictorial report by Edward Quinn in his book Picasso at

Work, New York, Doubleday, 1965, with an introduction by Roland Penrose.

Page 34, Alexey Brodovitch. There is no definitive work on this designer. The best current source of information is the catalogue of the exhibition at the Philadelphia College of Art called *Alexey Brodovitch and His Influence*, 1972.

Chapter 3 *Page 41, William Bernbach and Paul Rand*. The record of this important meeting is based on personal knowledge supported by an interview with William Bernbach by Richard Coyne, editor of *CA Magazine*.

Page 46, Brainstorming. This term was originally applied to group thinking by Alex Osborn in *Applied Imagination*, New York, Scribners, 1953.

Page 47, William Bernbach quotation. This is taken from Richard Coyne, *"An Interview with William Bernbach," Communication Arts Magazine*, 1967.

Page 49, Symbols. Paul Rand, *Thoughts on Design*, Chapter 3.

Page 53, "Unique Selling Proposition." This is a sales philosophy generally credited to Rosser Reeves.

Chapter 4 *Page 76, Esquire covers*. George Lois, *The Art of Advertising*, New York, Harry N. Abrams, pages 66–83.

Page 84, Format and Editorial Design. Allen Hurlburt, *Publication Design*, New York, Van Nostrand Reinhold Company, 1971, revised 1976.

Chapter 5 *Page 92, Logic and design*. Forrest Williams, "The Mystique of Unconscious Creation," an essay in *Creativity and Learning*, edited by Jerome Kagan.

Page 95, Diagraphics. Walter Herdeg, *Graphis Diagrams—The Graphic Visualization of Abstract Data*, Zurich, Graphis Press, 1974. Introduction by Leslie A. Segal.

Page 98, Pictograms. Rudolf Modley, *Handbook of Pictorial Symbols*, New York, Dover Publications, 1976; Henry Dreyfuss, *Symbol Sourcebook*, New York, McGraw-Hill, 1972; Gyorgy Kepes, ed., *Sign, Symbol, Image*, New York, Braziller.

146

Page 100, Identification. Ben Rosen, *The Corporate Search for Visual Identity*, New York, Van Nostrand Reinhold, 1970; Wally Olins, *The Corporate Personality*, London, The Design Center, 1979.

Page 104, Tom Wolf on Abstract Logos. This is from an article in *New York* magazine by Tom Wolf reporting on his experience in judging graphic design for an AIGA exhibition, July 17, 1972.

Page 109, Design Systems. Allen Hurlburt, *The Grid*, New York, Van Nostrand Reinhold, 1978.

Page 114, Connections. International Design Conference in Aspen, Colorado, June 1978. James Burke, *Connections*, a ten-part British Broadcasting Company series based on the events that influenced twentieth-century technological innovation. *Connections*, the catalogue for an exhibition of the work of Charles and Ray Eames with an essay by Ralph Caplan, published by UCLA Arts Council, Los Angeles.

Picture sources:

Many sources were used for this study of creative concepts in graphic design, beginning with my own archive of proofs and reproductions, but my main concentration has been on the *Annuals of Advertising and Editorial Art* published for over sixty consecutive years by the Art Directors Club of New York. Every year since 1920, the exhibitions on which these annuals are based have been selected by juries of contemporary graphic designers; as a result, they reflect standards and trends with a unique accuracy.

This selection by peer juries of Art Directors was not without its vagaries. The historic Hathaway shirt advertisement with its symbolic eye patch was only rescued from oblivion when Dr. Agha retrieved it from a reject bin at the last minute. The famous "Think Small" advertisement for Volkswagen made the show but failed to win the gold medal that in retrospect, it deserved. In spite of these and other lapses, this series still provides the best basis for a study of creative concepts.

Other publications that have served as valuable sources for pictorial material in this book are: *Communication Arts Magazine* and the *CA Annuals*, edited and published by Richard Coyne in Palo Alto, California; *Graphis* and the *Graphis Annuals*, published by Walter Herdeg in Zurich, Switzerland; and the collected publications of the American Institute of Graphic Arts. Other pictorial and informational sources include *Art Direction* and *Print* magazines in New York, *Design* and *The Designer* in London, and *Idea* in Tokyo.

Acknowledgments:

I am particularly grateful to the eight designers who contributed so much time and effort to the case histories in chapter six and to the many other

graphic designers whose work and ideas helped make this book **147**
possible.

I am also indebted to Don Holden and Marsha Melnick of Watson-Guptill
Publications for their early help and guidance in the planning of this book
and to Connie Buckley who saw it through the difficult editing stage.

Bibliography

Creativity:

de Bono, Edward. *Lateral Thinking*. London, Pelican Books, 1977.

Collier, Graham. *Art and the Creative Consciousness*. Englewood Cliffs, N.J., Prentice-Hall, 1972.

Freud, Sigmund. *An Outline of Psycho-Analysis*. Translated by James Strachey. London, Hogarth Press, 1969.

———— *The Complete Introductory Lectures on Psycho-Analysis*. Oxford, Alden & Mowbry, Ltd., 1971.

———— *Jokes and Their Relation to the Unconscious*. London, Routledge and Kegan Paul, 1960.

Ghiselin, Brewster. *The Creative Process*, New York, New American Library.

Koestler. Arthur. *The Act of Creation*. London, Hutchinson, 1964.

Osborn, Alex. *Applied Imagination*. New York, Charles Scribner & Sons, 1953.

Simberg, A. L. *Creativity at Work*. Boston, Industrial Education Unit, 1964.

Storr, Anthony. *The Dynamics of Creation*. London, Sacker & Warburg, 1972.

Wallas, G. *The Art of Thought*. London, Jonathan Cape, 1926.

Woodworth, R., and Schlosberg. *Experimental Psychology*. London, Methman & Company.

Design:

Arnheim, Rudolf. *Art and Visual Perception*. Berkeley, University of California Press, 1974; London, Faber and Faber, 1974.

150

Elffers, Joost, *Tangram, The Ancient Chinese Shapes Game*. London and New York, Penguin Books, 1976.

Garland, Ken. *Illustrated Graphics Glossary*. London, Barrie & Jenkins, 1980.

Gombrich, E. H. *Art and Illusion*. New York, Bollingen Series, 1961; London, Pantheon Books, 1960.

Herdeg, Walter. *Graphis Diagrams*. Zurich, Graphis Press; New York, Hastings House.

——— *Film & TV Graphics*. Zurich, Graphis Press; New York, Hastings House.

——— *Archigraphia*. Zurich, Graphis Press. New York, Hastings House.

Hoffman, Armin. *Graphic Design Manual*. New York, Van Nostrand Reinhold, 1965.

Hurlburt, Allen. *Layout, the Design of the Printed Page*. New York, Watson-Guptill Publications, 1977.

Hurlburt, Allen. *The Grid*. New York, Van Nostrand Reinhold, 1978.

Lois, George. *The Art of Advertising*. New York, Harry N. Abrams, 1977.

Gasser, Manuel. *Exempla Graphica*, An AGI Publication. Zurich, Hug & Sohne.

Glaser, Milton. *Graphic Design*. Overlook Press, 1973.

Kepes, Gyorgy. *Language of Vision*. Chicago, Theobald, 1945.

Kepes, Gyorgy. *Education of Vision*. New York, George Braziller, 1965.

Muller-Brockmann, Josef. *The Graphic Artist and His Design Problems*. New York, Hastings House, 1961.

Rand, Paul. *Thoughts on Design*. New York, Van Nostrand Reinhold, 1971.

Ruegg, Ruedi, and Frohlich, Godi. *Basic Typography: Handbook of Technique and Design*. New York, Hastings House, 1972.

Design Annuals: Art Directors Club. *Annual of Advertising and Editorial Art*, New York, 1921–present.

Herdeg, Walter. *Graphis Annual*. Zurich, Graphis Press; New York, Hastings House, 1952.

Coyne, Richard. *CA Annual of Design and Advertising*. Palo Alto, *Communication Arts Books*, 1958.

American Institute of Graphic Arts, *AIGA Graphic Design, USA*, New York, Watson-Guptill Publications, 1980.

Modern Publicity, London, Studio Vista.

Booth-Clibborn, Edward, ed. *Design and Art Direction, Nineteen Seventy Nine*, 17th Edition. New York, Hastings House, 1980.

Print Casebooks. Three six-volume editions of the best in graphic design from 1975 to 1980. R. C. Publications.

Index

Designed by Allen Hurlburt
Edited by Connie Buckley
Graphic Production by Hector Campbell
Set in 10 point Helvetica